Lincoln's legacy lives at Ford's Theatre.

Brian Anderson

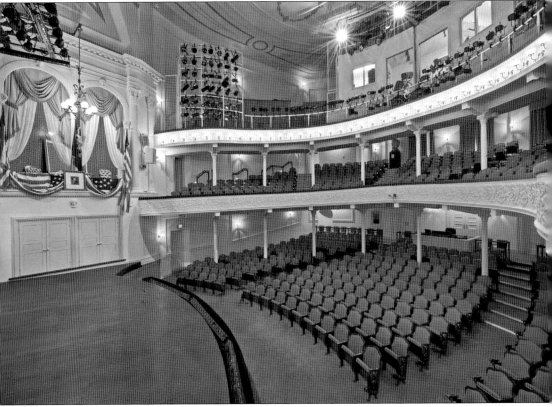

Ford's Theatre in Washington, DC, combines a historically accurate reproduction of the performance space as it existed on April 14, 1865—the night of President Lincoln's assassination—with the required amenities of a modern theater. This image shows the theater's interior, including the stage, Presidential Box, seating areas, and control booth, upon the completion of its most recent renovation in 2009. (Photograph © Maxwell MacKenzie; Ford's Theatre Society.)

ON THE COVER: Around 1900, the former Ford's Theatre was at the nadir of its existence. It had been 35 years since the building was last used for public entertainment, and it would be another 30-plus before the historic structure would become a public landmark of Lincoln's presidency. (Library of Congress.)

IMAGES of America
FORD'S THEATRE

Brian Anderson for
Ford's Theatre Society

ARCADIA
PUBLISHING

Copyright © 2014 by Brian Anderson for the Ford's Theatre Society
ISBN 978-1-4671-2112-5

Published by Arcadia Publishing
Charleston, South Carolina

Printed in the United States of America

Library of Congress Control Number: 2013946347

For all general information, please contact Arcadia Publishing:
Telephone 843-853-2070
Fax 843-853-0044
E-mail sales@arcadiapublishing.com
For customer service and orders:
Toll-Free 1-888-313-2665

Visit us on the Internet at www.arcadiapublishing.com

This book is dedicated to the people whose hard work, creativity, and support today make Ford's Theatre the premier Washington, DC, destination to learn about and enjoy Abraham Lincoln and his legacy. The book also is dedicated to my family—Merry, Eric, Laura, and Mark—who encouraged me to start, and finish, it.

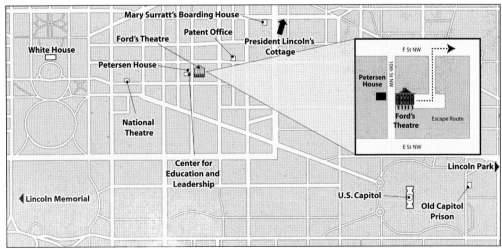

This map shows the location of Ford's Theatre in downtown Washington, with some current and historical reference points. (Map by Gary Erskine.)

Contents

Acknowledgments		6
Introduction		7
1.	1833–1859: Church	9
2.	1861–1865: Theater	21
3.	1866–1932: Office, Building, and Warehouse	49
4.	1932–1964: Museum	69
5.	1968–Today: Theater, Museum, and Education Center	95
Bibliography		126
About the Organization		127

Acknowledgments

This project was a team effort by talented people who contributed their different skills and expertise and who shared a commitment to make this book accurate, interesting, and complete.

Ford's Theatre Society interns Allison Hartley, Drew Barker, and Emma Bingham performed historical research, found relevant images, and managed the technical process of creating the book. Sarah Jencks, the society's director of education, managed this effort, introduced me to the right research librarians, interacted with Arcadia Publishing, and did basic research whenever necessary.

Ford's Theatre Society associate director of communications Lauren Beyea and art director Gary Erskine obtained or created many of the images in the book.

Lisa Cassara, Frankie Hewitt's daughter, sent us fascinating memorabilia from her family records about the early history of Ford's Theatre Society.

National Park Service museum technician Allison Dixon guided us through file cabinets filled with historical information and images. National Park Service rangers Eric Martin and Ricca Sarson and former historian Gary Scott answered our questions about the theater's history. Robert D. Cochran, of the District of Columbia Baptist Convention, educated us about the First Baptist Church. Eric Boyle, of the Otis Historical Archives at the National Museum of Health and Medicine, helped us obtain images of the Army Medical Museum once located in the building. The First Baptist Church of the City of Washington, DC, and the George Washington University both allowed us to photograph historic items in their possession.

Early drafts were reviewed and improved through the edits and comments of Ford's Theatre Society director Paul R. Tetreault, director of programming Kristin Fox-Siegmund, director of communications and marketing Liza Lorenz, deputy director of development Jennifer Kiefer Thomas, special events manager Alicia Brooks, programming operations manager Sarah Robinson, curator of exhibitions Tracey Avant, former National Park Service assistant superintendent Rae Emerson, former Library of Congress Civil War specialist John R. Sellers, and Anne Rollins of the Historical Society of Washington, DC.

Faye Haskins and Michele Casto, both of the DC Public Library Special Collections, and Michelle Krowl, Library of Congress Civil War specialist, helped find and obtain historical information from their institutions.

Deborah Reese, my assistant at O'Melveny & Myers LLP, took care of all clerical needs with her usual cheerfulness and efficiency.

Unless otherwise indicated, images in this book appear courtesy of Lisa Cassara (Cassara); Ford's Theatre Society (FTS); Historical Society of Washington (HSW); the Library of Congress, Prints and Publications Division (LOC); District of Columbia Martin Luther King Jr. Memorial Library, Washingtoniana Division (MLK); or National Park Service, Ford's Theatre National Historic Site (NPS).

INTRODUCTION

Ford's Theatre is primarily known as the place where, on the evening of Friday, April 14, 1865, Pres. Abraham Lincoln was assassinated by John Wilkes Booth. While this horrifying incident defines Ford's Theatre in American history, it represents only a tiny slice of the site's 180-year life.

Like most old commercial buildings, the structure called "Ford's Theatre" has served different purposes in different eras. It was built in 1833 as home to the First Baptist Church of Washington. For 26 years, a racially diverse congregation met here between the two centers of federal government—the Capitol building and the Executive Mansion. For most of those years, the presiding pastor was the Reverend Obadiah Brown, an influential Baptist leader and founder of Columbian College, now called the George Washington University.

In 1859, church leaders relocated the congregation to Thirteenth Street and put the building up for sale. John T. Ford, a theater owner and producer from Baltimore, Maryland, who long had wanted to expand his mid-Atlantic entertainment business to the Washington market, rented the structure in 1861 and later purchased it. After a massive fire in 1862, Ford reinvested in a new and opulent theater that attracted large crowds—including, on several occasions, President Lincoln, who enjoyed theater as a distraction from the burdens of his office. On April 14, 1865, Lincoln attended the 495th (and last) performance at Ford's New Theatre.

After the president's assassination, the building became a military crime scene controlled by the War Department. Regaining custody after the conspirators were captured, tried, convicted, and hanged, John T. Ford sought to resume his business, but unnamed citizens threatened to burn the theater down if he dared desecrate the site of Lincoln's death with what were widely viewed as morally questionable amusements. Ford sold the theater to the federal government, and over the next 77 years, the building served as a storage site for Civil War soldiers' medical records, a workplace for clerks making pension decisions for veterans, a medical museum, and editorial offices for preparation of a medical history of the Civil War. Those decades of bureaucratic use were interrupted in 1893 when an ineptly managed basement excavation project caused parts of all three floors to collapse. The incident killed 22 people, injured 65 others, and further embellished the theater's cursed reputation.

As the shock of President Lincoln's assassination faded with the passing decades, the desire to commemorate him grew. In 1896, the federal government purchased the Petersen boardinghouse where Lincoln had died and induced a collector of Lincoln memorabilia named Osborn Oldroyd to display his artifacts there. The maturation of the capital city, the 1909 centennial of Lincoln's birth, and the desire to honor aged Civil War veterans led to construction of the Lincoln Memorial. In response to this renewed interest in Lincoln, in 1932, the government moved the Oldroyd collection into a new Lincoln Museum on the first floor of the old Ford's Theatre building. In the years thereafter, the Petersen House (also known as "the House Where Lincoln Died") was, in stages, restored to its appearance at the time of Lincoln's death.

In the 1950s, as the centennial of the Civil War approached, Sen. Milton Young of North Dakota led a successful effort to appropriate Congressional funds to create a historically accurate

replica of the theater as it had been in 1865. The purpose behind this effort was to enable museum visitors to better visualize the events of the assassination. A team of federal government employees researched the structure's history and developed blueprints, and the theater was rebuilt in the mid-1960s. The Department of the Interior initially planned to use the theater for ranger talks and other related programming. But to Frankie Hewitt, a transplanted Oklahoman with connections in the government and entertainment worlds, failure to revive live theatrical performances at Ford's Theatre seemed a missed opportunity: the focus would be too much on John Wilkes Booth's crime and not enough on President Lincoln's character and values. After multiple conversations with then Secretary of the Interior Stewart Udall, Hewitt started a nonprofit organization called Ford's Theatre Society and persuaded government officials to allow the society to present live theatrical programming in the renovated space.

On January 30, 1968, entertainers sang, danced, and performed on the Ford's Theatre stage for the first time since the night of President Lincoln's assassination. The society has since worked with the National Park Service in one of the first examples of public-private partnerships enhancing programming at national historical sites. As a result of this partnership, Ford's Theatre welcomes guests not only to visit the historic building and museum galleries, but also to enjoy live theater, just as Lincoln did some 150 years ago.

In the 45 years since Ford's Theatre reopened after a century of darkness, its purpose and prominence have grown. Ford's Theatre Society cemented the theater's importance in Washington by hosting presidents and other political leaders in annual televised galas, which in turn attracted world-class performers and financial support for its mission. The historic site has become a significant destination for more than 650,000 annual visitors, many of them students coming from across the country for their first visit to the capital of the United States.

In 2007, the theater underwent a second major renovation, adding modern museum and lobby spaces as well as elevators and other conveniences. Ford's Theatre Society also created the Center for Education and Leadership across the street, adjacent to the House Where Lincoln Died. Programming at the site has evolved as well. Theatrical presentations bring different aspects of the American experience to life, while ranger talks, walking tours, and other activities provide visitors with a rich visit, which is augmented online at www.fords.org.

Today, 180 years after its initial construction, Ford's Theatre has moved beyond the identity John Wilkes Booth sought to impose upon it, as the place where Booth pulled off his most dramatic act by ending Lincoln's life and presidency. Instead, through the direct efforts of hundreds of people and the support of thousands more, Ford's Theatre now is a place where people come to learn about Lincoln, the values for which he stood, and his enduring impact on the nation.

One

1833–1859

Church

In the early 1800s, the humble reality of Washington, DC, fell far short of Pierre L'Enfant's ambitions for the new nation's capital city. Although L'Enfant's design featured wide avenues, grand ceremonial circles, and elaborate buildings reflecting a world power, the real Washington featured mostly dirt roads, empty lots, and a motley collection of boardinghouses, restaurants, markets, and small businesses. Its permanence and significance as the capital remained in doubt for many years as Northern and Southern states competed for influence over the young nation and debated the scope of the federal government's role.

In 1833, the First Baptist Church erected the building now known as Ford's Theatre to serve as the home of a congregation of middle- and lower-class parishioners, white and black, free and enslaved. Much of the building cost was borne by the church's pastor, Obadiah Brown, a prominent Baptist leader who traveled in the highest circles of Washington political society. During its quarter century on Tenth Street, the First Baptist Church taught literacy to Washington's uneducated masses. The building's time as a church ended in 1859 when the congregation moved to another site and put the structure up for sale.

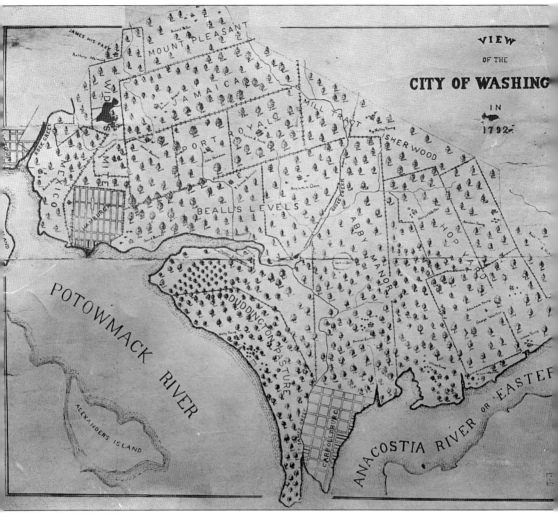

In 1790, after seemingly endless negotiations between representatives of the Northern and Southern states concerning the location of the national capital, Congress passed the Residence Act. This act empowered Pres. George Washington to build the capital on a 100-square-mile tract of land along the Potomac River. The autonomous federal district that President Washington defined took land from Maryland and Virginia and created a diamond-shaped area, 10 miles on each side, incorporating the port towns of Georgetown and Alexandria. Washington no doubt chose this location because it lay just downriver from the point where the Potomac River ceased to be navigable, making it both militarily defendable and accessible to oceangoing vessels. Also, Washington knew the region well, inasmuch as it was located just 15 miles upriver from his home at Mount Vernon. Washington believed it had great potential to serve as both the seat of government and an important economic hub of the new nation. This map shows the region in 1792. (LOC.)

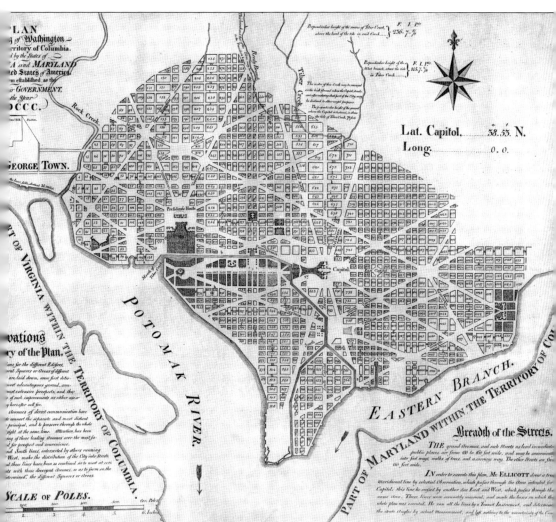

Washington retained French engineer Pierre L'Enfant to design the new federal capital. L'Enfant envisioned a grand, imperial city of wide avenues, circles, and squares. Reflecting the system of government established in the Constitution, he placed the gargantuan Capitol building (the seat of the legislative branch of government) on a pedestal-like hill and made it the focal point from which the district's streets and quadrants were established. L'Enfant placed the palatial President's House (headquarters of the executive branch of government) one mile west, with other major streets emanating from it. President Washington's plan to finance construction of these public buildings involved persuading the major landowners in the newly created city of Washington to donate to the federal government those areas designated for public buildings, sell half of their remaining land to the government for $67 an acre, and keep their remaining land. Washington assumed that auctions of the publicly and privately held lots in the new capital city (shown in this 1818 map) would raise money over time for the federal government while also profiting local landowners. (LOC.)

Although the Capitol and the President's House were sufficiently constructed by 1800 to allow Pres. John Adams and the rest of the federal government to move to Washington, development across the city proceeded slowly. After the British burned the main government buildings during the War of 1812, Congress considered moving the capital to a more developed and militarily defensible location. Instead, the Capitol and President's House were rebuilt, and the city slowly attracted government officials, businessmen, construction workers, shopkeepers, and hotel and tavern owners. The above engraving shows Washington in the 1830s; the below drawing shows how undeveloped the neighborhood near Pennsylvania Avenue and Seventh Street was as late as 1839. (Both, LOC.)

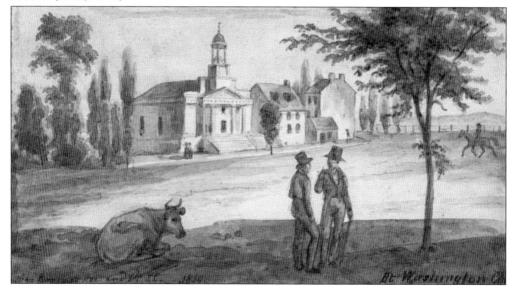

As Washington established a greater sense of permanence, churches arose around the city. Baptists initially met in the Treasury Building before the First Baptist Church acquired property on Nineteenth and I Streets. In 1807, Obadiah Brown, shown at right, was called to Washington to serve as its pastor. Reverend Brown also found employment at the Post Office Department and served as chaplain of the House of Representatives and, later, the Senate. Contemporaries described Brown as "a cheerful, jolly man, who loves good eating and drinking and delights in a joke. He is scarcely ever serious except at prayers and in the pulpit." Reverend Brown, called "one of the most important Baptists in American history," and others founded Columbian College in 1821. Originally located in the building shown here above Boundary Street (now Florida Avenue), the institution is now known as the George Washington University. (Right, photograph by Gary Erskine of portrait at the George Washington University; below, HSW.)

In 1820, Reverend Brown decided to build a "meeting house with tower and Sunday school auditorium" near Tenth and E Streets—an emerging population center between the Capitol and President's House. As shown on the map above, the land on which this church would eventually be built, as well as much of the land straddling Pennsylvania Avenue between the Capitol and the White House, was originally owned by a farmer named David Burnes. Burnes's farmhouse (shown below) was located at what is today the intersection of Seventeenth Street and Constitution Avenue, just southwest of the White House. Burnes profited handsomely through judicious and gradual sales of his landholdings after development in the city had begun. (Above, photograph by Gary Erskine of map from MLK; below, HSW.)

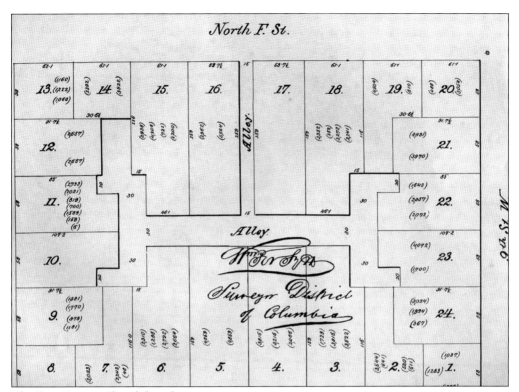

BAPTIST CHURCH CORNER STONE
LAID IN 1833
THE ORIGINAL FORD THEATER
DESTROYED BY FIRE DEC. 30, 1862

The First Baptist Church bought a lot on the east side of Tenth Street, between E and F Streets (shown on the above plat map as lots 10 and 11), in 1833. The seller was David Burnes's daughter Marcia Burnes Van Ness, who had inherited her father's fortune and whose husband was a former congressman and Washington's mayor. Van Ness was a prominent and popular member of Washington society who had worked with the Reverend Brown's wife, Elizabeth Riley Brown, in 1815 to open an asylum for destitute female orphans near Tenth Street and Pennsylvania Avenue. The Reverend Brown, who lived around the corner on E Street, contributed $8,000 (a sum equivalent to $160,000 today) to the establishment of the new church, shown at right. "Brown's Church," as the new worship facility sometimes was called, was completed in 1834. (Both, NPS.)

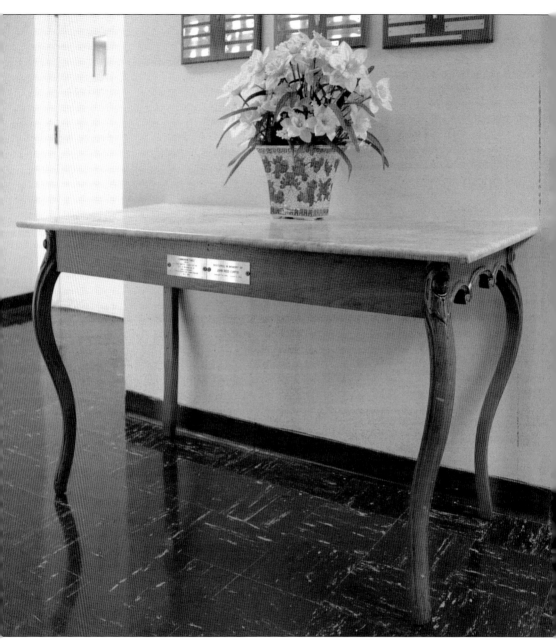

Brown's Church served Baptist parishioners who worked for the government or the businesses springing up along Pennsylvania Avenue. Unlike other area churches (including Baptist churches), which catered to separate races, the congregation of Brown's Church included whites, free blacks, and slaves. Indeed, in the early 1800s, the church was roughly evenly split between blacks and whites. Brown's Church was used as a worship facility and a Sunday school, and in 1819, it started a "Sabbath school," teaching literacy and scripture to illiterate blacks and working-class whites using the Bible. The building featured a raised stage, a pulpit, a lectern, and 78 curved pews. This altar table was used in the Tenth Street church building. Today, it occupies a place of honor at First Baptist Church's current location at Sixteenth and O Streets NW. (Photograph by Gary Erskine.)

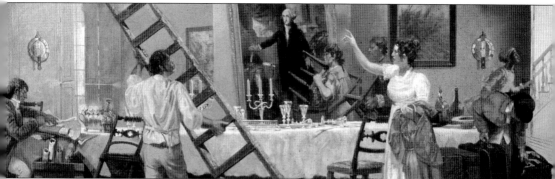

Perhaps the most historically interesting member of First Baptist Church was Paul Jennings, who was born in 1799 and grew up enslaved, owned by James Madison. When Madison assumed the presidency in 1809, a 10-year-old Jennings accompanied him to Washington. As portrayed in this mural, Jennings, holding a ladder, helped First Lady Dolley Madison save the George Washington portrait by Gilbert Stuart when the British burned the Executive Mansion in 1814. Although President Madison's will granted Jennings his freedom, Dolley Madison declined to do so, keeping Jennings as her servant until 1846, when she sold him. In 1847, Sen. Daniel Webster loaned Jennings the money to buy his freedom. Jennings, who was literate, earned enough money to buy his children's freedom and a home in downtown Washington. In 1848 (the year he joined First Baptist Church), Jennings planned the ultimately unsuccessful escape attempt of 77 enslaved men, women, and children from Georgetown Harbor aboard the ship *Pearl*. In 1865, Paul Jennings published the first known presidential memoir, documenting his service to the Madison family. He died in 1874. (The Montpelier Foundation, James Madison's Montpelier.)

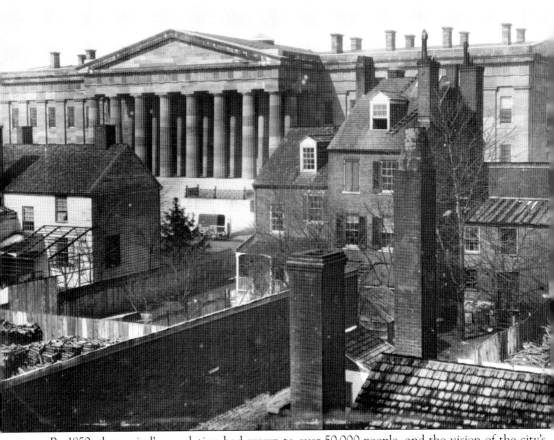

By 1850, the capital's population had grown to over 50,000 people, and the vision of the city's founders was beginning to be realized. The city's blocks contained government offices, housing for federal employees, hotels, boardinghouses, restaurants and taverns for temporary visitors, and stores and offices providing goods and services needed by residents. The Patent Office on F Street between Seventh and Ninth Streets, shown here in 1846, housed government workers who processed patent applications and stored the patent models. The British invaders of 1814 spared the building from destruction because they were persuaded that it contained private, not public, property. By the 1840s, it had become one of Washington's early tourist attractions. It displayed General Washington's sword and camp equipment, a copy of the Declaration of Independence, Benjamin Franklin's printing press, and locks of hair from all US presidents. During the Civil War, the building served as a hospital. Today, it houses the National Portrait Gallery and the Smithsonian American Art Museum. (LOC.)

The Reverend Brown retired as pastor of First Baptist Church in 1850. In 1859, under the Reverend Stephen P. Hill, shown at right, the church merged with the Fourth Baptist Church, which had a newer, larger facility on Thirteenth Street between G and H Streets NW. Because of the merger, First Baptist Church now had no further need for the 25-year-old building. To help pay off the church's substantial debt, the empty sanctuary was put up for sale. (Photograph by Gary Erskine of pen and ink drawing; First Baptist Church of the City of Washington, DC.)

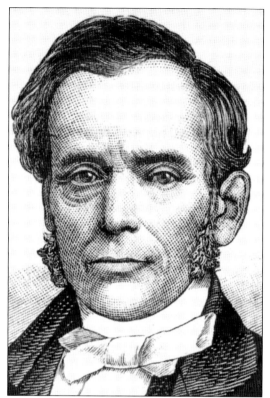

Unable to find a buyer immediately, First Baptist Church rented the building to the Presbyterian Church in 1859 and 1860, charging $10 per Sabbath. The Presbyterians needed a temporary home while they built a new house of worship on New York Avenue, shown here. Abraham Lincoln regularly attended services at this church during his presidency. (LOC.)

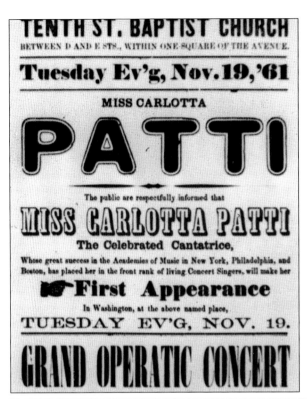

The unused church building was occasionally rented out for operatic and other performances, as shown in this advertisement. While some members of the congregation frowned upon amusements like music, theater, and drinking, most Baptists during this era accepted them in moderation, especially when they brought their church needed revenue. (NPS.)

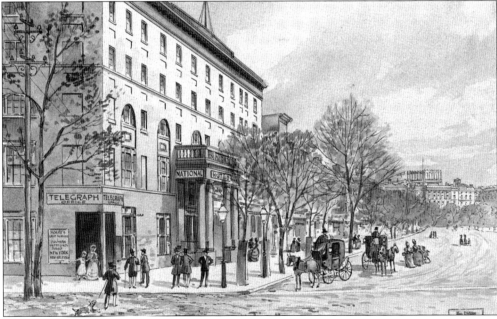

On the eve of the 1860 presidential election and the threatened dissolution of the Union, the mood in Washington was epitomized by the half-finished Capitol dome, shown in the background of this drawing of the National Hotel. The city was emerging, but its future was threatened. If the Union dissolved, Washington would be replaced by a more northern city as the national capital, while the Confederacy's capital would be farther south. (Watercolor by A. Meyer; LOC.)

Two

1861–1865
Theater

The year 1861 began an era of growth and change in Washington, DC. The inauguration of President Lincoln in March coincided with the outbreak of the Civil War, which drew tens of thousands of soldiers, civilian workers, and war contractors to Washington. This influx of people expanded economic activity in the city, including demand for amusements to distract citizens from the stress of war.

Into this mix came John T. Ford, part of a Baltimore-based family of theatrical producers who arrived in Washington in 1861 to scout sites for the expansion of his portfolio of theaters (he already managed a theater in Baltimore). Finding the Tenth Street Baptist Church site available, he rented and shortly thereafter bought the building, reconfiguring it to create what was initially called Ford's Athenaeum. A catastrophic fire in December 1862 set him back, but he raised funds and rebuilt the space into a first-class entertainment destination, which reopened in August 1863 under the name Ford's New Theatre. It was a business and cultural success, attracting large crowds—including President Lincoln on 10 occasions—to theatrical and musical performances.

On April 14, 1865, the future looked bright for the nation, for Washington, and for Ford's Theatre. With the April 9 surrender of Confederate general Robert E. Lee, the city celebrated, and President Lincoln made plans to attend the theater that night for a benefit performance of a popular comedy, *Our American Cousin*. But prominent stage actor and Confederate sympathizer John Wilkes Booth had other plans. That evening, Booth shot Lincoln in the Presidential Box overlooking the stage and then escaped into the night. Lincoln was carried across the street to a boardinghouse, where he died the next morning.

Born in a Kentucky log cabin to illiterate parents, Abraham Lincoln became a self-taught Illinois lawyer, state legislator, one-term congressman, unsuccessful Senate candidate, and, in November 1860, president-elect of the United States. Lincoln said of this photograph, taken in June 1860, "That looks better and expresses me better than any I have ever seen; if it pleases the people I am satisfied." (Photograph by Alexander Hesler; LOC.)

When President Lincoln was inaugurated on March 4, 1861, at the east front of the Capitol, Washington was a divided city about to go war. A postelection peace conference had failed to preserve the Union, and Southern states were rapidly seceding. Even Washington's mayor had been removed from office and imprisoned for refusing to swear allegiance to the US government. (LOC.)

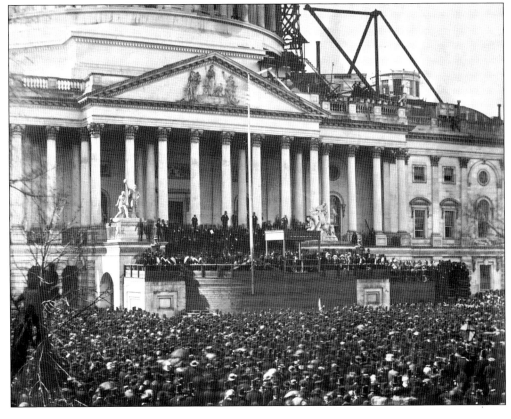

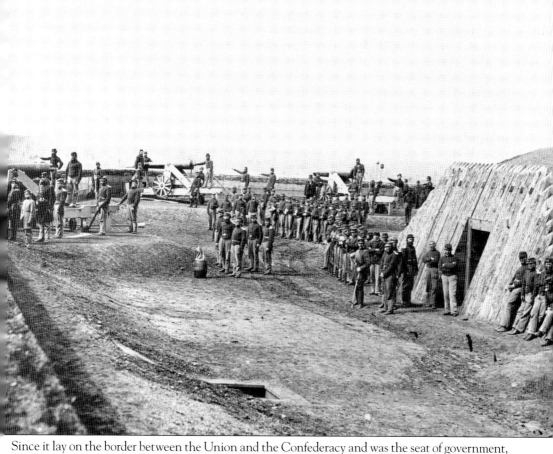

Since it lay on the border between the Union and the Confederacy and was the seat of government, Washington was on the front lines of the war. By late summer of 1861, there were 50,000 Union soldiers stationed around the northern edge of the city, including at Fort Totten (shown here), three miles north of the Capitol. In July 1864, Abraham Lincoln watched a battle at nearby Fort Stevens during which he came under Confederate fire. (Photograph by Mathew Brady; National Archives & Records Administration.)

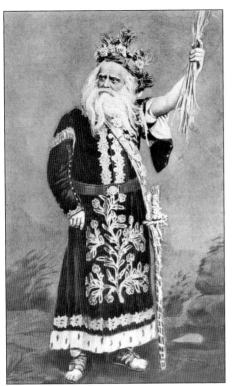

Although theater had long been popular in England, America's more puritanical society questioned the propriety of frivolous amusements that lacked religious grounding and featured actors of low morality and rowdy audiences. Several colonies banned theater outright. The Continental Congress resolved in 1774 that any government official attending the theater should be dismissed as unworthy to hold office. Nevertheless, George Washington attended the theater during his presidency, and its popularity grew. In the early 1800s, English productions (often Shakespearean tragedies) dominated the stages of America's major cities. A handful of star actors, like Edwin Forrest (pictured at left), toured the country. Forrest played King Lear at Ford's Theatre in 1864, and he and other actors enjoyed broad acclaim. In 1835, Washington's National Theatre (shown below) became a venue for such performances at Thirteenth and E Streets, a location it still occupies today, although in a newer building. (Left, LOC; below, National Theatre Archives.)

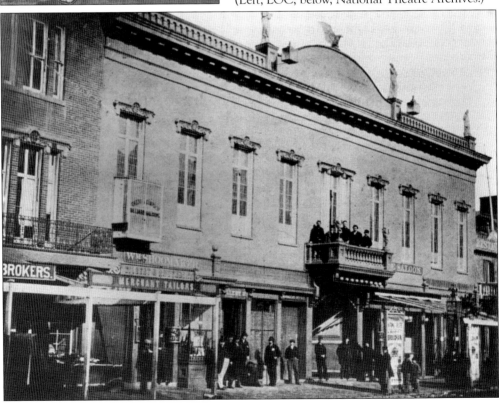

John T. Ford was the eldest brother of a Baltimore-based family of theatrical producers. Born in 1829, he eventually grew interested in the business. In 1851, Ford moved to Philadelphia and began managing a troupe of theatrical performers. In 1854, he and two partners began managing theaters in Baltimore, Richmond, and Washington. Ford was primarily responsible for the Holliday Street Theatre in Baltimore and, briefly, Washington's National Theatre. The partnership dissolved in 1857, whereupon Ford concentrated on running the Baltimore theater. By December 1861, with tens of thousands of soldiers, entrepreneurs, and job seekers descending upon Washington, Ford concluded that the time was ripe to make a second attempt at cracking the Washington market. Ford had a good reputation among the star actors who traveled around the country performing Shakespearean and other dramatic plays, making him well positioned to open a new theater in Washington. (NPS.)

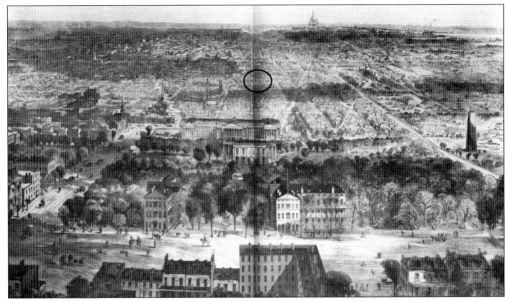

Despite reservations expressed by some church members about turning a house of worship into a theater, the First Baptist Church leased the building to Ford for 10 years with the right to purchase it later for $10,000. It was common for theater owners to minimize costs by converting churches (which already had stages and seating) into performance spaces. This drawing shows Washington around the time of Ford's purchase, with the location of Ford's Theatre circled. (NPS.)

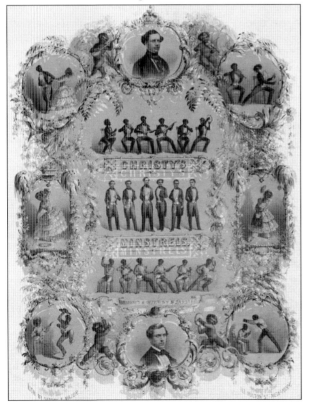

Testing the Washington market before opening his own theater at the site, Ford initially sublet the First Baptist Church building to George Christy, who presented minstrel shows from December 1861 to February 1862. These were variety shows aimed at working-class audiences and featured white performers appearing in blackface and performing comedy sketches, slave songs with dancing, and skits based on plantation life. (LOC.)

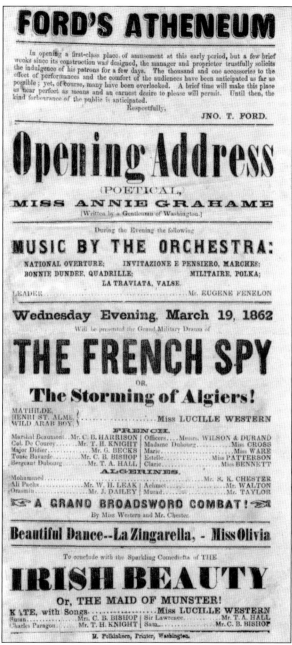

After Christy's sublease ended, Ford remodeled the building, adding a dome and 1,200 seats. He also had murals painted on the walls to represent the seasons. Ford's Athenaeum opened on March 19, 1862. Aiming for a higher class of patrons, Ford presented a mix of Shakespearean plays, shows emphasizing early American values, light comedies, and the occasional variety show. President Lincoln made his first visit to Ford's on May 28, 1862, to see a musical concert. Ford's successful run would be short-lived. At approximately 5:00 p.m. on the evening of December 30, 1862, the building was destroyed by fire. The blaze, apparently caused by a defective gas meter in the cellar, spread quickly and damaged structures on both sides of the theater. Although there was no loss of life, the overall damage was estimated at $20,000. (LOC.)

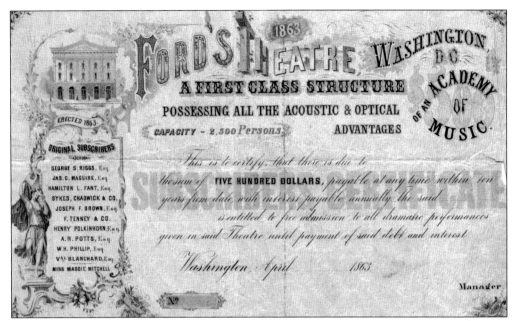

Ford decided to rebuild his theater on the same site but on a grander scale. Raising over $75,000 from investors (about $1.4 million today) through bond certificates (shown above), Ford exercised his right to buy the core property from the First Baptist Church and also purchased two adjoining lots to facilitate a modest expansion. He then designed a completely new theater and personally supervised the construction, which began in February 1863. As seen in the comparative image below, the exterior of the Tenth Street theater closely resembled Ford's Holliday Street Theatre in Baltimore. Ford overcame Civil War–era constraints on obtaining building supplies and made many improvements to the new theater, including an enlarged dressing room, a saloon, and living quarters for Ford's two brothers: Harry, his treasurer, and James, his business manager. (Above, LOC; below, NPS.)

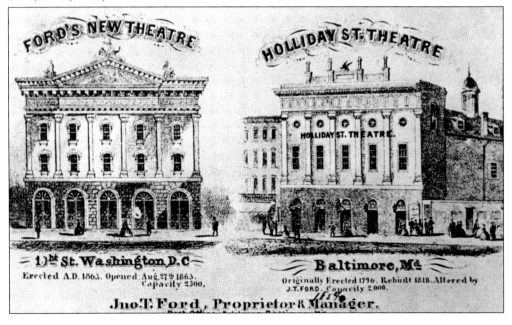

John T. Ford sought to maximize revenue at Ford's New Theatre by creating different levels and prices of seating for different classes of patrons. The Orchestra (or "parquette") level contained 602 moveable, cane-bottomed wooden chairs set in curved rows, plus four private boxes (two on each side of the stage at stage level). Patrons entered these seats from the front lobby. Two curved niches in the back of the theater (still there today) likely contained either stoves for heating or busts of theatrical personalities. The Dress Circle (second) level of the theater contained 422 seats. Patrons reached this level by ascending a curved staircase from the theater lobby. The Dress Circle featured four private boxes above the stage, which cost $10 each. Ticket prices for other Dress Circle seats ranged from 50¢ to $1 (about $10–$20 today). (Both, NPS.)

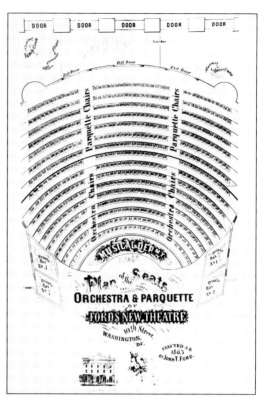

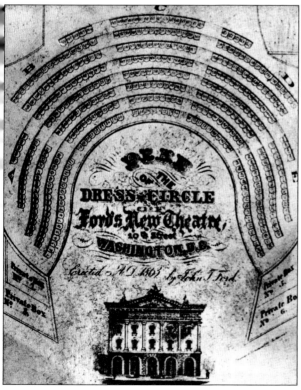

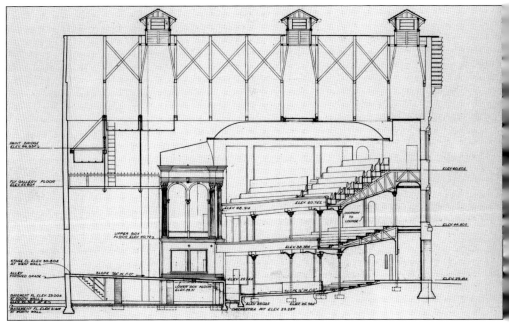

As shown in this 1960s-era blueprint of the theater's cross section, the Family Circle (third) level contained high-backed wooden benches seating about 600 people. The Family Circle was above the Dress Circle and Orchestra levels. Family Circle patrons (whose tickets cost 25¢) entered the theater through a separate entrance at the south end of the building and ascended two flights of stairs to their seats. (NPS.)

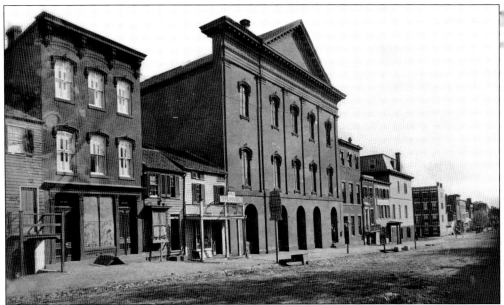

After the renovation, Ford's New Theatre opened on August 27, 1863, with a performance of *The Naiad Queen*. The *Washington Sunday Chronicle* wrote, "Mr. Ford has shown what can be done when capital, skill, and energy are combined . . . He has erected a substantial theater which will be an acquisition and an ornament to the city . . . In magnitude, completeness, and elegance it has few superiors, even in our largest cities." (LOC.)

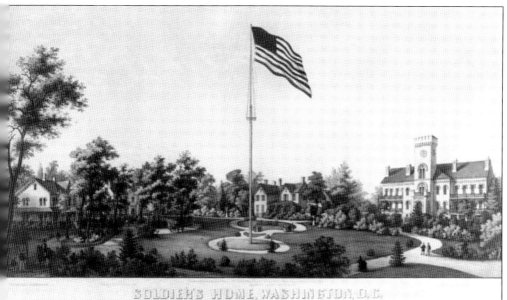

President Lincoln found several ways to escape the pressures of his presidency. Beginning in 1862, his family spent each summer and fall living in what became known as the Lincoln Cottage at the Old Soldiers' Home in the hills north of the Capitol. There, they could escape the heat and malarial swamps of downtown Washington as well as the chaos of the president's workplace at the Executive Mansion. Lincoln spent a quarter of his presidency at the cottage, commuting the five-mile distance by horseback, accompanied by light security. The informality of the setting allowed Lincoln to think, and it was there that he drafted the Emancipation Proclamation in 1862. President Lincoln's Cottage has been restored and today is open to the public (www.lincolncottage.org). (Both, LOC.)

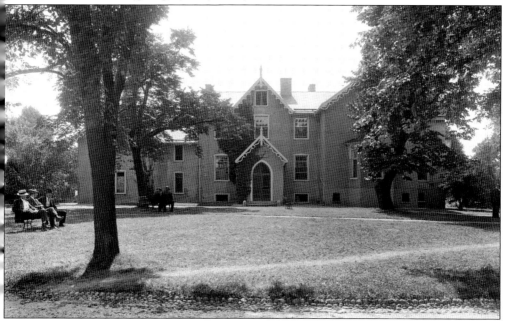

> **FORD'S NEW THEATRE.**
> *Tenth Street, near E.*
>
> JOHN T. FORD - - - - - Proprietor and Manager
> (Also of Holliday street Theatre, Baltimore.)
>
> MONDAY EVENING, NOVEMBER 9, 1863.
> Last Week of
> MR. J. WILKES BOOTH,
> And Messrs. CHAS. WHEATLEIGH,
> HARRY PEARSON,
> G. F. DE VERE,
> AND THE GRAND COMBINATION COMPANY
>
> **THE MARBLE HEART.**
>
> Phidias.. } Mr. J. Wilkes Booth.
> Duchalet }
> Diogenes } Mr. Chas. Wheatleigh.
> Volage }
> Georgias } Mr. Harry Pearson.
> Chateau Margeau }
>
> ON TUESDAY—HAMLET.
>
> ADMISSION:
> Dress Circle........50 cents | Orchestra Chairs....75 cents
> Family Circle.......25 cents | Private Boxes....$10 and
>
> ☞ Box Sheet now open, where seats can be secured without extra charge. nov 4—

President Lincoln viewed the theater as another source of diversion. He once remarked, "Some people think I do wrong to go to the opera and the theater. But it rests me . . . A hearty laugh relieves me, and I seem better able after it to bear my cross." In November 1863, Lincoln attended three performances at Ford's in one week, including *The Marble Heart*, starring John Wilkes Booth. (NPS.)

John T. Ford had every incentive to improve the public image of his theater. He found creative ways to do so that foreshadowed crowd-pleasing events that still occur at Ford's Theatre today. In February 1865, he presented a "grand ball" in honor of George Washington's birthday. Although Ford invited government and military leaders to attend the event, there is no record that President Lincoln came. (MLK.)

> **FORD'S THEATER.**
> THE ONE HUNDRED AND THIRTY-THIRD
> ANNIVERSARY
> OF THE
> BIRTHDAY
> OF
> GEN. GEORGE WASHINGTON,
> FIRST PRESIDENT OF THE UNITED STATES,
> FEBRUARY 22, 1865.
> It will be observed in this splendid theater by
> GRAND BALL AND PROMENADE CONCERT
> WITH
> GYMNASTIC EXERCISES
> BY
> ABNER S. BRADY,
> Late principal of the Seventh Regiment Gymnasium, St. Mark's Place, New York, now of Brady's Gymnasium, Washington,
> AND HIS PUPILS.
> THE RENOWNED
> HANLON BROTHERS,
> George, William, Thomas, and Alfred.
> The most distinguished Gymnasts of this or any other country have returned from their South American tour, and will, in compliment to Mr. Brady visit Washington, to
> APPEAR ON THIS OCCASION ONLY.
> The Ball and Promenade Concert will be conducted with the same LIBERALITY,
> DISCRIMINATION,
> AND EXCLUSIVENESS
> as distinguished the Grand Balls at the Academy of Music, New York.
> The Theater will be most brilliantly illuminated and gorgeously decorated with
> EVERGREENS,
> ONE HUNDRED SINGING CANARY BIRDS,
> AND FINE PAINTINGS.
> Also, TWO GRAND BANDS—one for Promenading and one for Dancing—so there will be
> NO CESSATION OF MUSIC
> DURING THE EVENING.
> The invited guests will embrace
> THE PRESIDENT OF THE UNITED STATES
> THE MEMBERS OF THE CABINET,
> AND THE MILITARY AND NAVAL CELEBRITIES IN OR NEAR WASHINGTON.

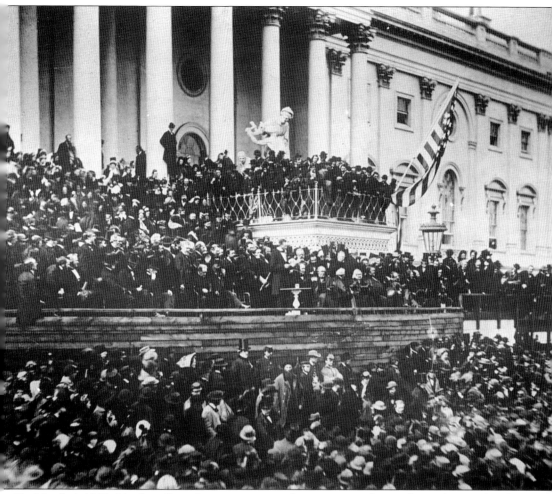

On March 4, 1865, Abraham Lincoln was inaugurated again as president in front of a completed Capitol dome. The war was almost over. The Confederate vice president, Alexander Stephens, had proposed peace terms to Union general Ulysses S. Grant in February. Congress had just approved and sent to the states for ratification the 13th Amendment to the Constitution, which would abolish slavery. In his second inaugural address, Lincoln's thoughts turned to reconstruction as he promised the South that he would proceed "with malice toward none." One man in the audience, John Wilkes Booth, nevertheless harbored malicious intent toward Lincoln. He was then plotting to kidnap the president and take him to Richmond. After the Confederacy fell in early April and Lincoln began talking of granting voting rights to freed slaves, Booth broadened his plan to decapitate the leadership of the federal government and encourage a final Confederate offensive. With several conspirators, Booth hatched a plot to kill Lincoln, Vice Pres. Andrew Johnson, and Secretary of State William H. Seward. (LOC.)

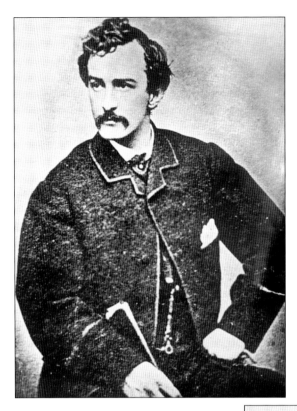

Baltimore-born dramatic actor John Wilkes Booth was known across both the North and South for his dashing looks and athletic leaps and poses. However, he had trouble reconciling his acting ambitions with his staunch Confederate sympathies. In 1863, he was arrested and briefly imprisoned for making remarks about President Lincoln and the government that were deemed treasonous. (LOC.)

Son of the legendary English actor Junius Brutus Booth and brother of the prominent actor Edwin Booth, John Wilkes Booth was handsome and popular with the ladies. He toured nationally, often receiving glowing reviews. His final performance at Ford's Theatre occurred on March 18, 1865, when he starred in *The Apostate*. (LOC.)

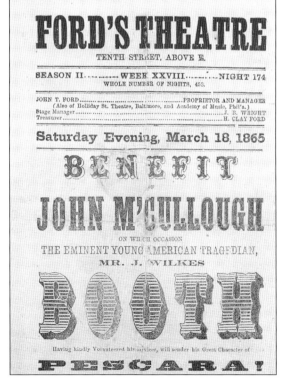

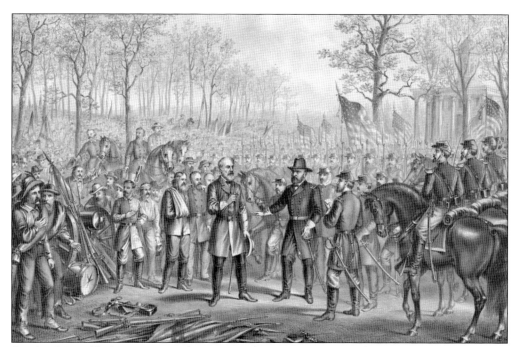

On April 9, 1865, about one month into Lincoln's new term, Confederate general Robert E. Lee surrendered at Appomattox Courthouse, Virginia, beginning the end of the war. News of the surrender inspired celebration in Washington; there were spontaneous parades, saloon parties, guns fired in joy, and, on the evening of April 13, a "grand illumination." Homes and public buildings in Washington glowed with candles, torchlights, gaslights, and fireworks. (LOC.)

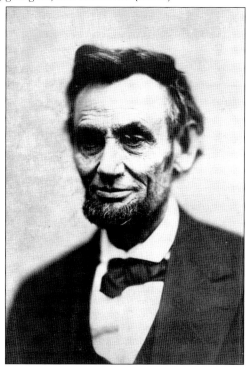

President Lincoln decided to celebrate by spending an evening out with his wife. At 10:30 a.m. on Friday, April 14, a message arrived at Ford's Theatre advising that the Lincolns and the victorious General Grant and his wife would attend that evening's closing-night performance of *Our American Cousin*. The Ford brothers were thrilled. Lincoln's 10th visit to Ford's Theatre would surely fill it on what otherwise would have been a slow Good Friday evening. (LOC.)

Our American Cousin is a farce in which an awkward, boorish American travels to England to inherit a family estate and contends with his gold-digging, snobbish English relatives. It premiered in New York in 1858 to great acclaim and remained popular throughout the remainder of the 19th century. Patrons enjoyed laughing at the buffoonery of English aristocrats displayed in the show. Its headline performer was Laura Keene, an English actress who had become a female theatrical pioneer. She was the first woman in America to manage theaters, direct performances, and be a star performer. Shown here are a newspaper advertisement and ticket for the performance on April 14, 1865. (Left, LOC; below, NPS.)

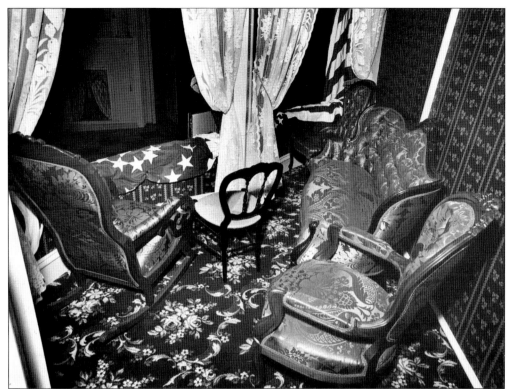

When Ford rebuilt his theater in 1863, he included eight private boxes, with four overlooking each end of the stage, and installed removable partitions between the upper boxes so he could accommodate large groups like a presidential party. Because the boxes were above the stage and faced the audience, their occupants' view of the performance was less than ideal. However, they put high-profile occupants on view to the audience. To make Boxes 7 and 8 (which Lincoln used and which Ford called the Presidential Box) more grand on this historic occasion, an upholstered sofa and rocking chair were brought from the Ford brothers' office. In a nod to the national celebration attending this presidential visit, the box was decorated with a bunting of flags and a portrait of George Washington. (Both, NPS.)

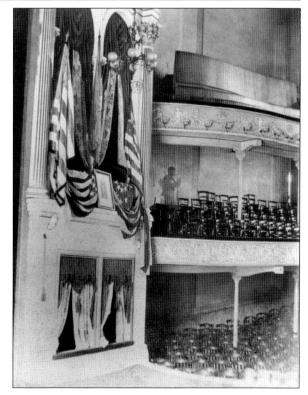

The Grants cancelled at the last minute, and Mary Todd Lincoln invited her friend Clara Harris (shown here), the daughter of New York senator Ira Harris, and Clara's fiancé, Maj. Henry R. Rathbone, to accompany the president's party. The Lincolns arrived 30 minutes late for the performance. As the group arrived, the show stopped, the band played "Hail to the Chief," and the audience roared its approval. (National Archives & Records Administration.)

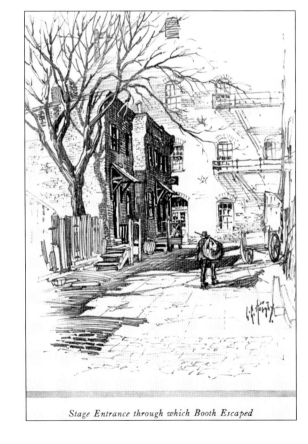

Stage Entrance through which Booth Escaped

Having learned earlier that day of Lincoln's expected appearance at the theater, John Wilkes Booth decided to kill Lincoln that night while others simultaneously attacked Johnson and Seward. At 9:00 p.m., he arrived at the alley behind the theater (shown here) and left his horse with a boy who sold peanuts to the audience. Booth entered the backstage of the theater, then left and went to the Star Saloon for a drink. (MLK.)

Around 10:00 p.m., Booth returned to the theater, walked around the back of the Dress Circle, and gave his card to the messenger at the door of the passage leading to the Presidential Box. No guard was on duty to prevent Booth from approaching the president. Perhaps due to Booth's fame, Lincoln's messenger made no effort to stop him. Entering the short hallway to the box as shown in the drawing at right, Booth used a stick of wood to wedge the door shut behind him. Because he knew the script of *Our American Cousin*, Booth timed his attack to coincide with a laugh-inducing line that would muffle the gunshot and distract the crowd. When the line was delivered, Booth entered Lincoln's box, stepped behind the president, and fired one shot at the back of his head with a small Deringer pistol. (Right, NPS; below, LOC.)

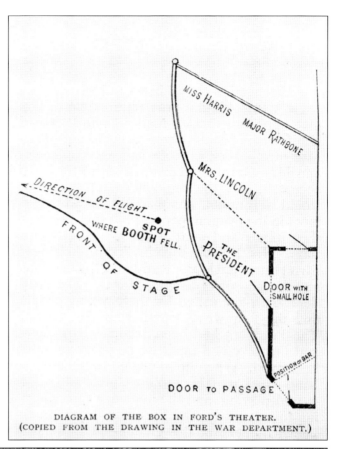

DIAGRAM OF THE BOX IN FORD'S THEATER. (COPIED FROM THE DRAWING IN THE WAR DEPARTMENT.)

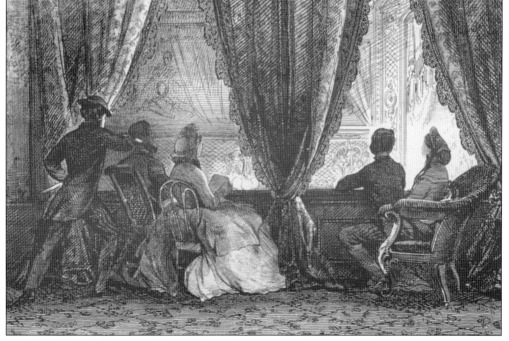

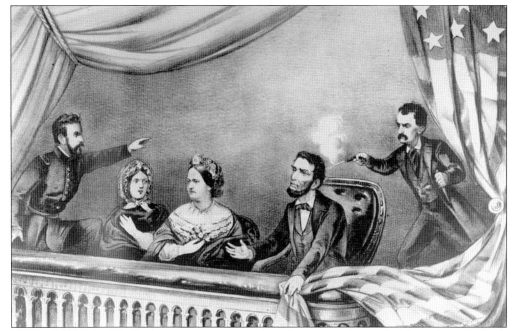

Major Rathbone was the first to react, rising from his seat to lunge for the assassin. Booth responded by attacking Rathbone with his large knife, slicing deeply into his upper arm. Mary Todd Lincoln and Clara Harris froze in shock as the actors and audience slowly began to notice the commotion in the Presidential Box. (LOC.)

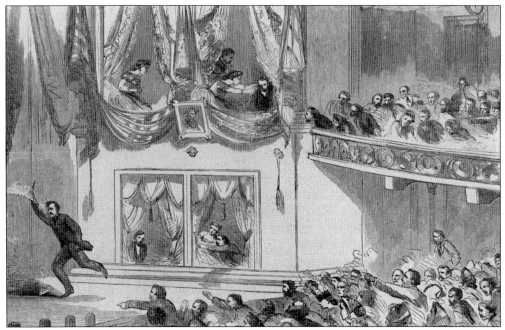

Commencing his escape, Booth jumped over the front railing of the box. He caught his spur on a flag and landed awkwardly on the stage 10 feet below. Hobbling on an injured leg to center stage, Booth, ever the dramatic actor, faced the audience and shouted, "*Sic semper tyrannis!*" ("Thus always to tyrants," a historical reference to the slaying of Caesar) and "The South is avenged!" (NPS.)

Booth ran toward the back of stage right, waving his knife at stunned cast members and stagehands, as Major Rathbone shouted from the box, "He has shot the President!" One patron leaped from his first-row seat up to the stage and gave chase as Booth ran out the rear stage door and into the alley, where the peanut seller was holding his horse. Jumping up to his saddle, Booth pushed the boy aside, evaded the pursuing theatergoer who had just reached the alley, and rode off down F Street. The drawing at right, made later by John T. Ford, shows Booth's movements. Booth proceeded southeast past the Capitol, crossed the Anacostia (formerly called Eastern Branch) River via the Navy Yard Bridge (shown below) with his coconspirator David Herold, and escaped into southern Maryland. (Both, LOC).

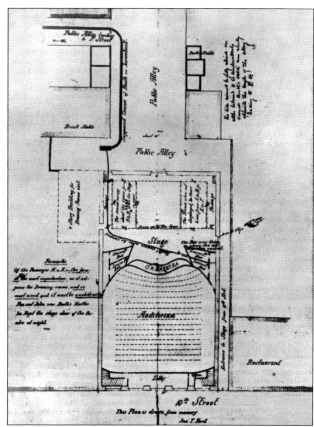

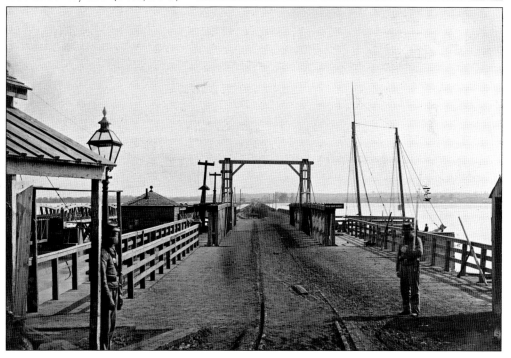

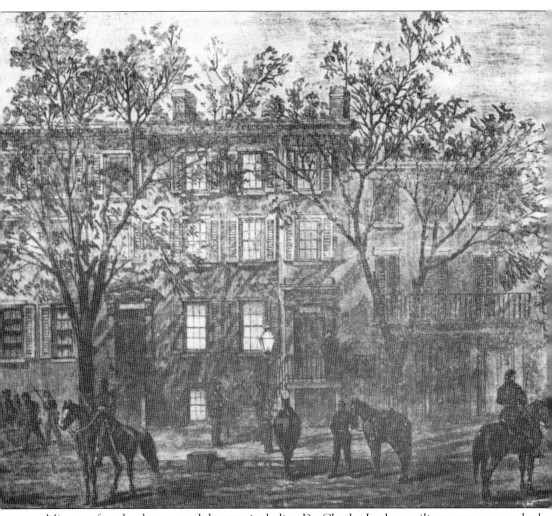

Minutes after the shot, several doctors, including Dr. Charles Leale, a military surgeon, reached the box to examine the unconscious president. Finding the bullet wound in the back of his head, Leale concluded immediately that it would prove fatal. Believing it would be undignified to allow President Lincoln to die on the floor of the theater, the doctors lifted him up and carried him around the back of the Dress Circle, down the spiral staircase, and out through the lobby. Bringing Lincoln into the chaotic, crowd-filled street, the doctors realized that he would not survive the six-block carriage ride to the Executive Mansion. They decided that he instead should be taken to a house near the theater. At that moment, Henry Safford, a resident of the Petersen boardinghouse directly across the street (see center of drawing) who had come outside to investigate the commotion, beckoned the party, which carried Lincoln into another boarder's bedroom and placed his six-foot, four-inch body diagonally on the bed. (LOC.)

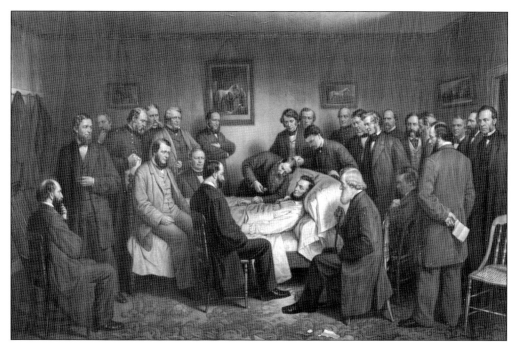

Surrounded as the night progressed by his distraught wife, eldest son Robert, doctors, friends, and government officials, Lincoln lay unconscious, slowly dying. At 7:22 a.m. on Saturday, April 15, he drew his last breath. Alexander Hay Ritchie later created this imagined death scene, which includes far more people than could have fit in the tiny bedroom at once. (LOC.)

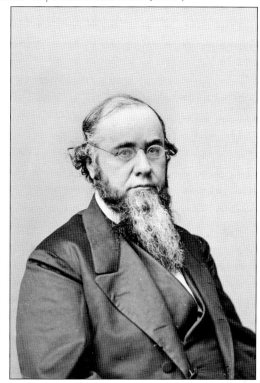

Secretary of War Edwin Stanton, the most powerful man in Washington after the president, had immediately gone to the Petersen House upon learning of the attack on Lincoln. Stanton, shown here, turned the back parlor into a command center for the management of the crisis. When Lincoln died, he marked the moment by saying, "Now, he belongs to the ages." (LOC.)

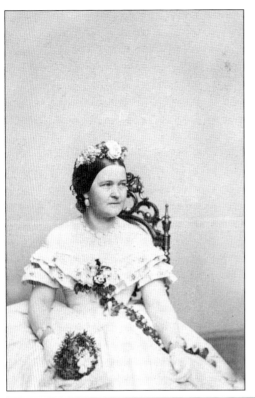

First Lady Mary Todd Lincoln, long an emotionally fragile person, had spent the night alternating between the front parlor and Lincoln's bedside until she suffered a bout of hysteria at 3:00 a.m., after which Stanton banished her from Lincoln's room. She would never see her husband again. Robert Lincoln gave her the news of his father's death, but Mary Lincoln was too anguished to view his body after he died. Escorted out of the Petersen House 90 minutes later, Mary Lincoln looked at Ford's Theatre through the morning drizzle and proclaimed, "Oh, that dreadful house." The site had now become a crime scene. Military guards had been posted at all entrances, and access was limited to those with War Department passes. (Left, photograph by Mathew Brady, LOC; below, NPS.)

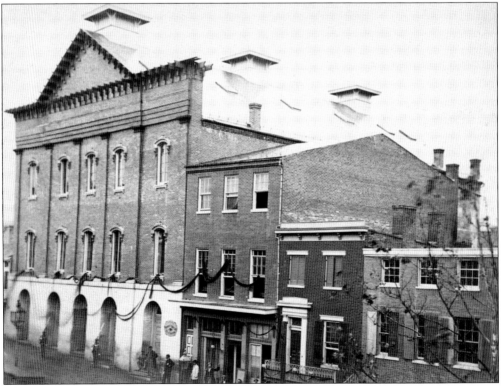

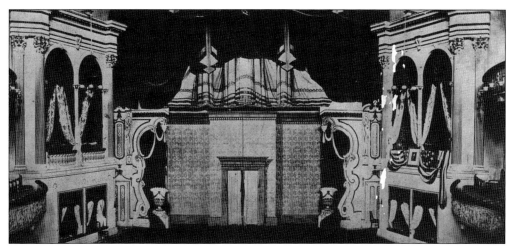

Later that day, Stanton visited the theater as part of his investigation of the murder. Souvenir hunters had already stripped Lincoln's box of its flags and bunting, but the rest of the site looked normal. Stanton retraced Booth's steps through the theater and directed a few cast members to reenact for him the pivotal part of *Our American Cousin*. Stanton decided that a photographic record should be made of the crime scene and so ordered photographer Mathew Brady to take pictures of the theater stage and the Presidential Box (shown above). Brady (pictured at right) and his associates had earned prominence by making photographs of famous Americans (including President Lincoln) as well as soldiers heading off to war. He had also documented many Civil War battlefields, causing some to label him the father of photojournalism. (Above, NPS; right, LOC.)

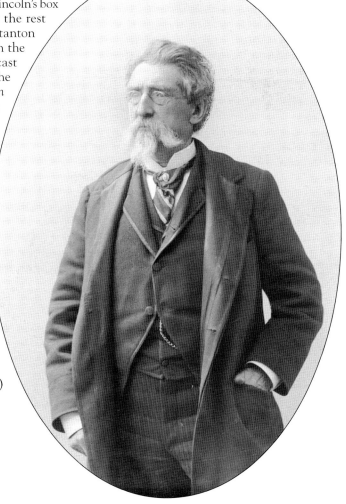

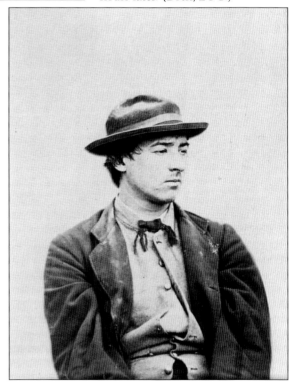

While Booth was assassinating Lincoln, Lewis Powell was severely wounding Secretary of State Seward at his home near the White House. George Atzerodt, assigned to kill Vice President Johnson in his downtown hotel room, backed out at the last minute. Because of the shocking assault upon the government's leadership and the uncertainty about its origins or scope, Secretary of War Stanton launched a broad public manhunt to identify and capture anyone who may have been involved. Meanwhile, Booth and Herold (shown below) gradually made their way from southern Maryland across the Potomac River to Virginia. Eventually, Union soldiers tracked them down near Port Royal, Virginia, where they were hiding in a barn belonging to Richard Garrett. Although Herold surrendered, Booth did not. He was shot and died three hours later. (Both, LOC.)

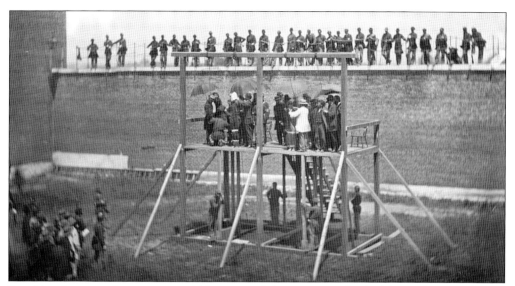

Booth's other conspirators were quickly captured. In a country shocked by its first presidential assassination, the political climate demanded swift and severe punishment, and Stanton made sure it occurred. Four of the conspirators—Lewis Powell, David Herold, George Atzerodt, and Mary Surratt—were tried and convicted by a military tribunal and, as shown above, hanged on July 7, 1865, at present-day Fort McNair, located at the confluence of the Potomac and Anacostia Rivers. (Surratt, who had hosted meetings of the conspirators at her H Street boardinghouse, shown below, was the first woman executed by the federal government.) Other convicted conspirators received lesser sentences. (Both, LOC.)

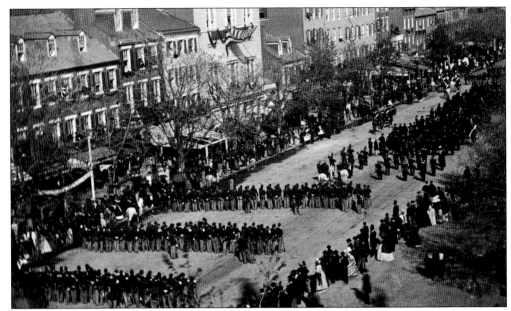

Abraham Lincoln's death launched a 20-day funeral process. His body was taken to the Executive Mansion on April 15, where an autopsy was performed in an upstairs guest room. On Monday, April 17, Lincoln's coffin was brought down to the East Room, where thousands of mourners came to pay respects on April 18. After a funeral on Wednesday, April 19, attended by about 600 guests, a huge procession (shown above) followed his casket down Pennsylvania Avenue to the Capitol Rotunda for further public viewing. On April 21, the bodies of Lincoln and his son Willie, who had died in 1862, were placed on a special train that stopped for public ceremonies in several major cities, including Chicago (shown below). On May 3, the train arrived at his home in Springfield, Illinois, where Lincoln was buried several weeks later. (Both, LOC.)

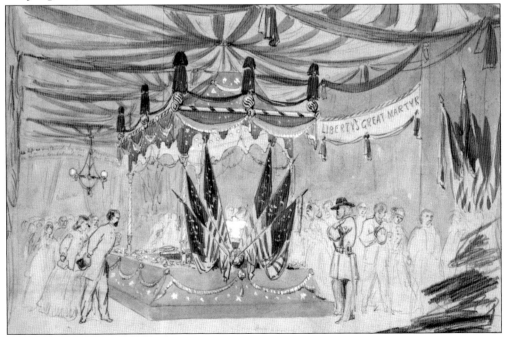

Three

1866–1932
Office Building and Warehouse

Abraham Lincoln's assassination at Ford's Theatre created a dilemma the nation had never faced and one that continues to resonate today: What should be done with the site of a presidential assassination?

Should the site remain as is, with no acknowledgment of the tragic event with which it is associated? Should it be made into a memorial to honor the victim? Should it be destroyed in the hope that the public will more quickly forget what occurred there?

After Lincoln's death, Secretary of War Edwin Stanton seized control of Ford's Theatre as part of his investigation of the crime. Several months later, John T. Ford regained custody of his theater and sought to reopen it for performances. Almost immediately, adverse public reaction (including a threat to burn it down) caused the War Department to again take possession of the building. Stymied, Ford leased and eventually sold it to the federal government and returned to Baltimore. The government gutted the former theater, turning it into a three-story office building. The first two floors were used to store and process veterans' pension records, while the third floor housed an Army Medical Museum and the surgeon general's library.

In 1887, the museum and library moved out, and the Office of Records and Pensions took over the entire building. In 1893, tragedy struck again. Construction in the building's basement weakened the piers supporting the upper floors, which collapsed, killing 22 workers and injuring another 65. After the collapse, the building was repaired and used as a warehouse for the next 40 years.

Meanwhile, the boardinghouse where Lincoln died changed hands from the Petersen family to the Schade family, who planned to use it as a private residence but were besieged by curious tourists. In 1896, the federal government bought the building and allowed Osborn Oldroyd—a Civil War veteran and collector of Lincolniana—to occupy the house and, with his extensive collection, turn it into a museum about Lincoln's life and death. For years, Oldroyd lived there and charged tourists for entry until his death in 1930.

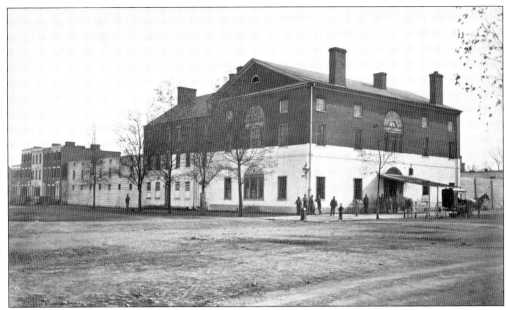

On the night of the assassination, John T. Ford was visiting Richmond, Virginia. On Tuesday, April 18, Ford and his two brothers were arrested at his family home in Baltimore as part of Secretary of War Stanton's sweeping manhunt. Ford was incarcerated at the Old Capitol Prison (shown above), so named because Congress met there while the Capitol was rebuilt after being burned in 1814. The Ford brothers were released on May 27 after it was established that they had played no role in the crime. After the real conspirators had been tried, convicted, and then executed on July 7, 1865, Ford obtained access to his theater and announced the opening of his next production, *The Octoroon*, which had been originally scheduled to begin April 15 but was rescheduled for a July 10 opening. (Above, LOC; below, NPS.)

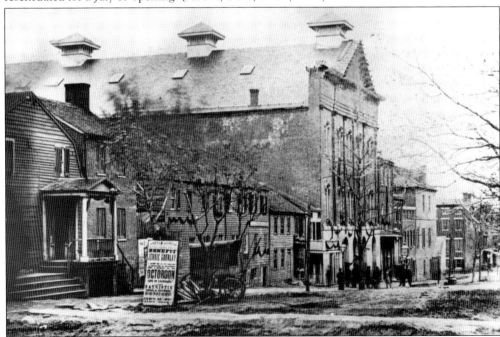

Although Ford quickly sold 200 tickets for the performance, the proposed resumption of business triggered an uproar. Ford received the following anonymous letter: "You must not think of opening tomorrow night. I can assure you it will not be tolerated. You must dispose of the property in some other way." The letter was signed, "One of the many determined to prevent it." (Maryland Historical Society.)

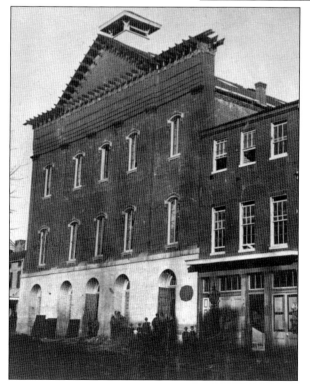

Fearing violence, on July 10, the government again ordered soldiers to close the theater. Ford placed a sign at the door that read, "Closed by Order of the Secretary of War." An angry Ford wrote to the *New York Herald*, "The government might as well confiscate New York Harbor because many meet death there by drowning." He then filed suit to obtain compensation for his seized property. (NPS.)

Through his actions, John Wilkes Booth not only killed a president, he killed a theater. With the building again in government hands, the question became what to do with it. The YMCA announced plans to buy the property, preserve it, and create "the Abraham Lincoln Memorial Temple," an idea that quickly died for lack of funding. Secretary of State Seward, who recovered from his wounds, proposed using it for religious purposes, but that idea also failed to gain support. In July 1865, the government leased the building for one year, with an option for purchase. (Stanton had been unable to obtain a congressional appropriation for an immediate acquisition.) Stanton had a contractor tear out the theater interior and build three stories of offices so that the government would be forced to buy the structure before the lease expired. One year later, on July 12, 1866, the federal government bought the building from Ford for $88,000 (more than $1.2 million today). This is the memorandum of sale. (NPS.)

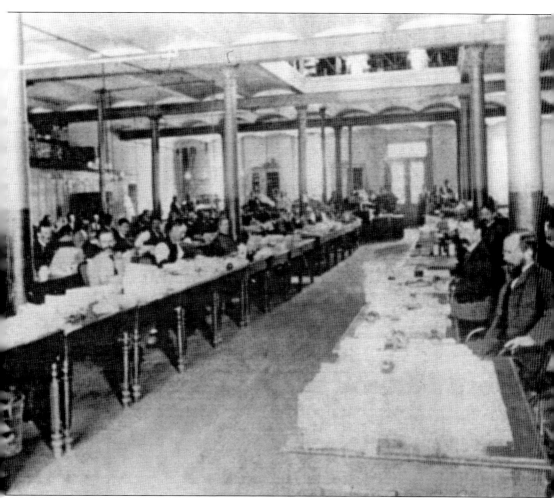

The first two floors of the redesigned building housed the Office of Records and Pensions, a government agency that processed pension requests by Civil War veterans. These floors housed soldiers' military and medical records as well as the several hundred clerks (shown here) who handled claims. The second floor also contained the library of the surgeon general's office (which maintained several thousand medical reference books and journals), and editorial offices for the preparation of a multivolume *Medical and Surgical History of the War of the Rebellion*. The third floor housed a newly established Army Medical Museum. An atrium from the first floor to the top floor in the center of the building, expanded windows in the front, and new windows installed in the back of the building provided enhanced lighting for these activities. (NPS.)

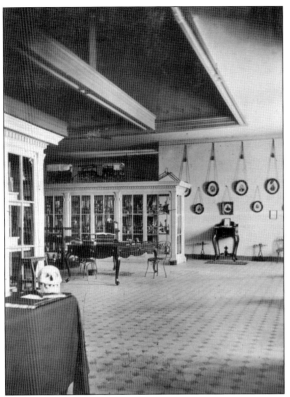

Opened on April 13, 1867, almost two years to the day after the assassination, the Army Medical Museum contained a macabre assortment of body parts illustrating the effects of war's medical and quasi-medical treatments. The museum included an extensive collection of human skulls, including those of "flat-headed Indians"; animal skeletons; bodies of soldiers displayed near sketches of the Civil War battlefields where they were killed; and mummified Indians. Bizarrely, the museum held part of John Wilkes Booth's spine, identified not by name but by his date of death: April 26, 1865. A woman writing about her time in Washington observed, "[A]ll that remains of [Booth] above the ground finds its perpetual place a few feet above the spot where he shot his illustrious victim." (Both, Otis Historical Archives at the National Museum of Health and Medicine.)

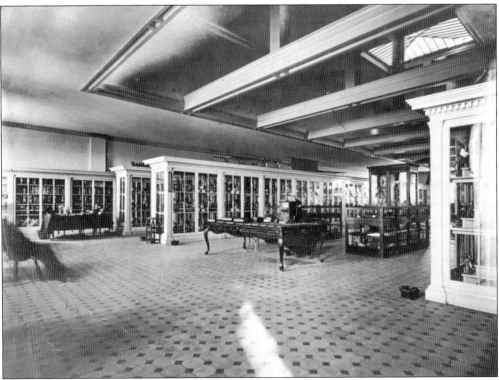

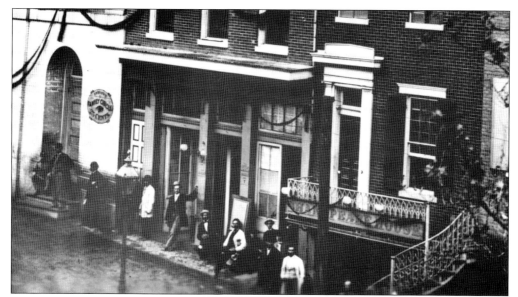

John T. Ford had built the Star Saloon as part of his 1863 renovation. The first floor of this three-story building contained a bar owned by Peter Taltavull; it was there that John Wilkes Booth had a whiskey and water before killing President Lincoln. Like the theater, the Star Saloon closed after Lincoln's assassination. (NPS.)

Over the next 75 years, the former Star Saloon housed a tailor, a hot water heater store, a manicurist, a typewriter company, and a factory. During World War I, it was a military recruiting station. The building was torn down in 1930 to create a parking lot. Today, the facade of the Star Saloon has been reconstructed, while the interior contains offices for National Park Service employees. (Photograph by Gary Erskine, FTS.)

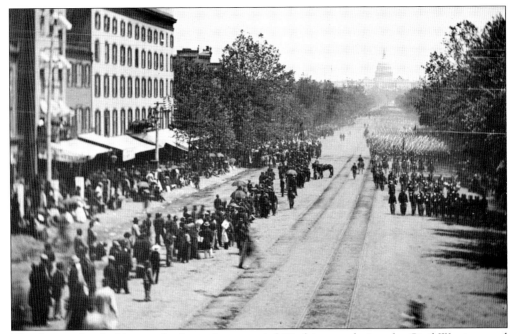

The thousands of soldiers and others who occupied Washington during the Civil War imposed great wear upon the city. Congress nevertheless refused to appropriate the funds necessary to improve the city's infrastructure or provide education and social services for its low- and middle-income residents. Consequently, as shown in this May 1865 image of the Civil War victory parade down Pennsylvania Avenue, the capital city had a shabby air about it. (LOC.)

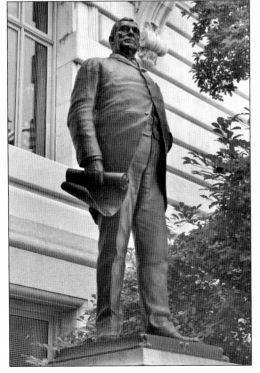

In the 1870s, a new Board of Public Works—led by Alexander "Boss" Shepherd, whose statue is shown here—launched a series of massive projects to improve the city's infrastructure through rebuilding streets, laying sewers and gas pipes, planting trees, and installing streetlights. These projects placed the city in debt and spawned allegations of corruption, but they also reduced unemployment and spurred the development of new neighborhoods. (Photograph by Gary Erskine; FTS.)

In 1887, the Office of Records and Pensions took over the third floor of Ford's Theatre and hired a new chief, Col. Fred Ainsworth, shown here. Ainsworth imposed higher standards and workloads upon the roughly 500 clerks who processed veterans' pension claims, making him unpopular among his employees. He also sought to improve the physical condition of the building, installing new heating and plumbing systems in 1888 and 1889. (LOC.)

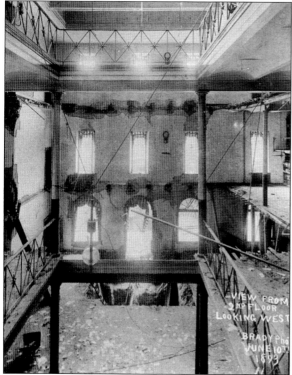

In 1893, Ainsworth began a construction project that required excavating 12 feet into the ground under the basement. While construction was under way, the clerks expressed concern about the building's structural safety. On Friday, June 9, 1893, at 9:30 a.m., a supporting pier in the basement excavation area collapsed, bringing down all three floors of the building. Shown here is the collapsed area as seen from the rear interior of the building. (NPS.)

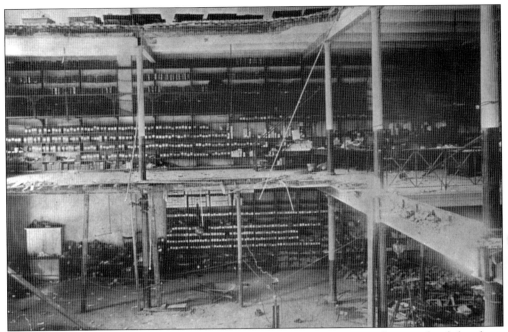

As the supporting pier in the basement collapsed, a 40-foot section from each of the three floors above gave way. Flooring, desks, records, and clerks plunged to the basement. This image shows the caved-in section as well as the areas that remained, including shelves of pension records. (NPS.)

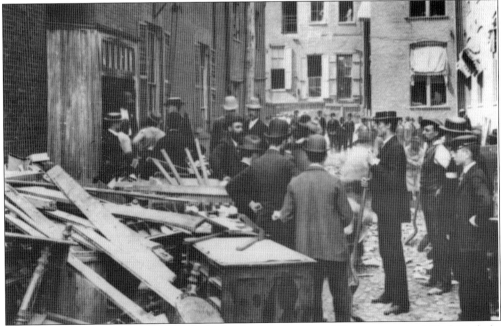

Here, workers are shown cleaning out the back of the building. The catastrophe killed 22 clerks and injured 65 others. Some observers fixated on the fact that the edifice had just suffered its second major fatal tragedy and concluded that it was cursed because of its previous conversion from church to theater. (NPS.)

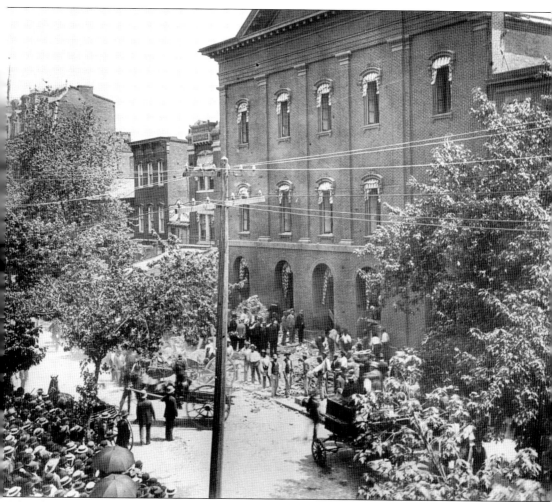

After the bodies were removed and the rubble cleared, workers and the public demanded that someone be held accountable for the collapse. A coroner's inquest was held to determine if anyone was criminally responsible. The surviving clerks testified that Colonel Ainsworth was to blame for the disaster, saying they had long warned Ainsworth that the building was unsafe, but he had ignored them. The jurors of the inquest found Ainsworth, the contractor, and several others guilty of criminal negligence and recommended prosecution. The ultimate decision whether to prosecute, however, rested with the district attorney, who concluded that the jurors' decision was motivated by passion more than reason and decided not to prosecute Ainsworth. His prosecution of the contractor, whose failure to properly shore up the building before excavating the basement in fact caused the collapse, was eventually dropped. Congress later voted to pay $5,000 to the families of each worker who died and from $50 to $5,000 for those who were wounded. (NPS.)

WALLS NOT WEAK.

Mr. Ford Says No Part of the Original Theatre Fell or Caused Any Injury.

TO THE EDITOR OF THE HERALD:—

In sheer justice to truth, one who has been a reader of the HERALD for nearly fifty years begs space for some facts and a little brief comment as to Ford's Theatre, Washington. It was built, entirely new, in 1863, thirty years ago. It was used and occupied by large audiences for nearly five hundred nights prior to the assassination in 1865. Very frequently the audiences were numbered by thousands and crowded the aisles and lobbies after occupying the seats. No intimation or evidence of any structural weakness of the building or of possible danger, during its legitimate uses, ever reached my ears.

In the disaster of last Friday no part of Ford's Theatre—i. e., the walls and the roof—fell or caused any personal injury. In fact, their positive strength stood the terrible concussion of air produced by the falling of the government floors and prevented a much greater loss of life, for if the walls and roof had given way to the fearful pressure of condensed air that sent dust fifty feet or more above the roof through the windows the victims would have been numbered by hundreds instead of tens. With these every way apparent facts I beg this hearing in the columns of your great journal.

Mr. T. B. Entwistle, a practical builder and the Inspector of Buildings in Washington, eminently qualified for his duties, has precisely defined the cause of the disaster in your Sunday issue. Mr. James J. Gifford, who erected the theatre, now an octogenarian in this city, without conference or knowledge of Mr. Entwistle's judgment, assigned the cause of the accident in exactly the same direction.

Ford's Theatre, unhappily associated with two terrible calamities, did not contribute in any way to the injury of a single person on Friday last. What was of it afforded protection by the strength and permanency of its walls and roof.

JOHN T. FORD.

BALTIMORE, June 11, 1893.

Brought back into the public eye by tragedy a second time, John T. Ford published this letter denying suggestions that his original construction methods had caused the collapse. After selling the building in 1866, Ford had returned to Baltimore to continue running the Holliday Street Theatre and, in 1871, built Baltimore's Grand Opera House. He even returned to Washington in 1877, opening Ford's Grand Opera House on Ninth and C Streets. Ford was a respected businessman who, for a time, served as president of the Union Railroad Company and a trustee of the Baltimore & Ohio Railroad. He also was a Baltimore civic leader—he had served on the city council and as acting mayor in the 1850s and later in life was a trustee of several philanthropic organizations. Ford died in 1894. (LOC.)

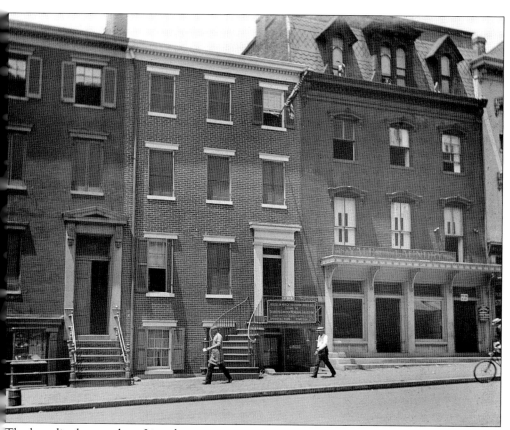

The boardinghouse where Lincoln died, shown in the middle of this early-1900s image, was built in 1849 by William Petersen, a German tailor. It was a three-story building with a basement slightly below street level. Since the house was larger than his family required, Petersen rented extra rooms to lodgers. As many as 21 people lived there at any given time during the Civil War years. (LOC.)

Petersen and his wife both died in 1871. Their heirs auctioned off the furniture from the room where Lincoln died and later sold the house to Louis Schade for $4,500. Schade used the building as a home and office for his newspaper, the *Washington Sentinel*. Although it was unmarked, tourists often knocked at the door asking to see the death room. In 1883, a marble tablet was affixed to the house, identifying its place in history. (LOC.)

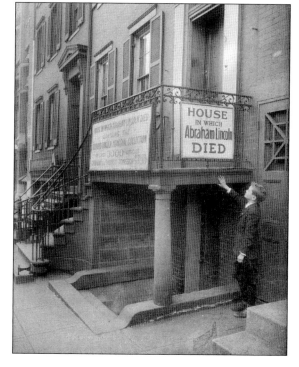

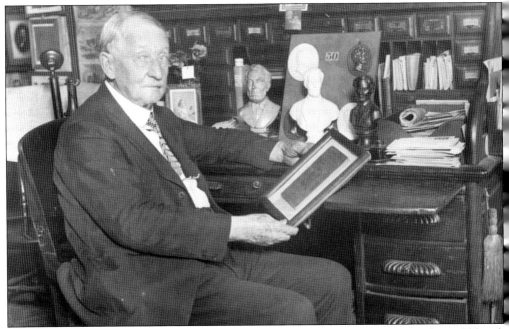

Ford's Theatre and the Petersen House might have met obscure ends if not for Osborn Oldroyd. A native of Ohio, Oldroyd became a great fan of Abraham Lincoln during the 1860 presidential campaign and thereafter determined to acquire every Lincoln artifact he could. He enlisted in the military in 1861 at age 19 and served until he was injured at the Battle of Vicksburg. (NPS.)

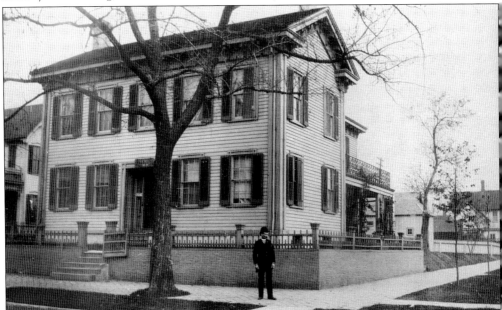

After the war, Oldroyd resumed collecting Lincoln memorabilia. In 1883, he moved to Springfield, Illinois, and, finding Lincoln's home (shown here) vacant, rented it from Robert Lincoln, President Lincoln's son. There, he displayed his Lincoln collection and charged visitors a small fee. In 1887, the State of Illinois bought the Lincoln home but allowed Oldroyd to continue living there rent-free. A Democratic governor elected in 1893 ended the arrangement. (LOC.)

By 1893, Louis Schade had grown weary of visitors dropping by to visit the death room and share their feelings about Lincoln. He leased the house to the Memorial Association of the District of Columbia, which invited Oldroyd to bring his Lincoln collection there and live at the site rent-free as its custodian. In this image taken in the mid-1920s, Oldroyd poses on the front stoop of the house. (LOC.)

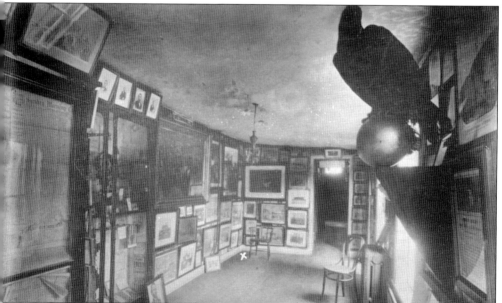

Oldroyd crammed over 3,000 objects into the house, covering virtually every square inch with things like the Lincoln family Bible, a cradle, Lincoln's chair from his White House office, a log from Lincoln's original house, a rail split by Lincoln, furniture from Lincoln's Springfield home, and various photographs, documents, newspapers, and campaign pamphlets. The white "X" in this image marks the location of the bed where Lincoln died. (LOC.)

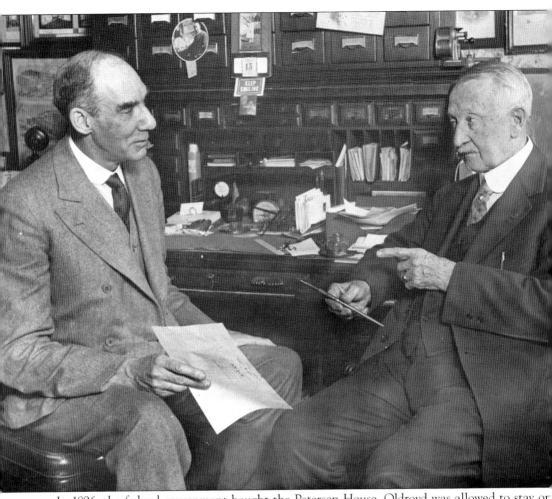

In 1896, the federal government bought the Petersen House. Oldroyd was allowed to stay on as its curator and charge visitors a small entrance fee. In this image, Osborn Oldroyd (right) is shown with Congressman Henry Riggs Rathbone (left), the son of the Lincolns' guests at Ford's Theatre the night of the assassination. Rathbone's father went on to marry Clara Harris in 1867, have three children, and be appointed US consul to Hanover, Germany. But he never got over Lincoln's death, blaming himself for his perceived failure to protect the president from Booth. His mental condition deteriorated, and in 1883, he murdered his wife and attempted suicide. Sent to an asylum, he died in 1911. The future Congressman Rathbone was born in 1870 on what would have been President Lincoln's 61st birthday. He became a Chicago lawyer and served in Congress from 1923 until his death in 1928. In 1926, Rathbone arranged for the government to buy Oldroyd's Lincoln memorabilia collection for $50,000. (NPS.)

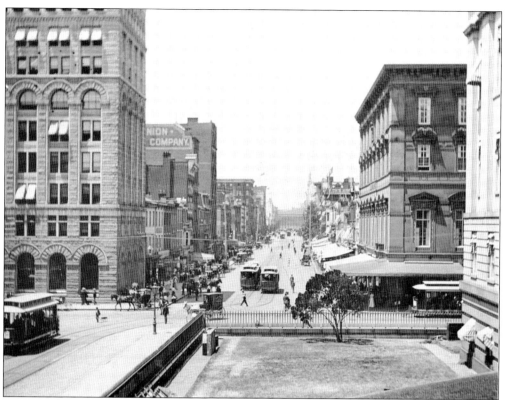

Between the 1880s and World War I, Washington's population more than doubled to almost 440,000, as expansion of the federal government created more jobs for government employees and those in the private sector who supported them. This photograph, taken around 1900 from the Patent Office at Ninth Street, looks down F Street past the bustling downtown shopping area and toward the Treasury Building. (MLK.)

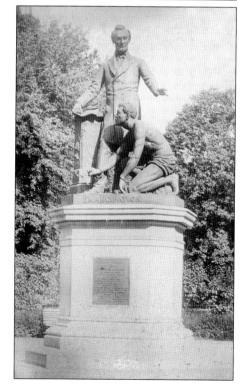

Different groups of people in different eras have applied their own perspectives to Abraham Lincoln's memory when choosing how to memorialize him. The Emancipation Monument erected in 1876 in Lincoln Park on Capitol Hill depicted Lincoln with a slave kneeling at his feet, an interpretation that later spawned controversy for portraying African Americans as supplicants. (LOC.)

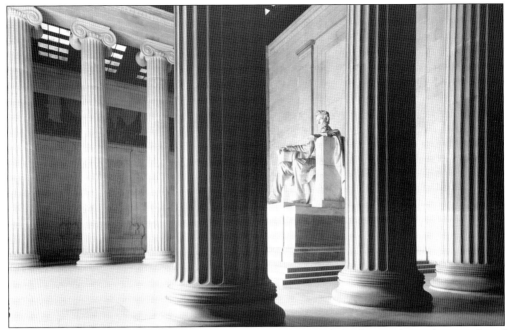

By contrast, the Lincoln Memorial, dedicated in 1922, promoted the theme of Lincoln as unifier of the nation. Lincoln sits in a Greek temple with 36 columns representing the states in the restored Union at the time of his death. Above is the epitaph, "In this temple, as in the hearts of the people for whom he saved the Union, the memory of Abraham Lincoln is enshrined forever." (LOC.)

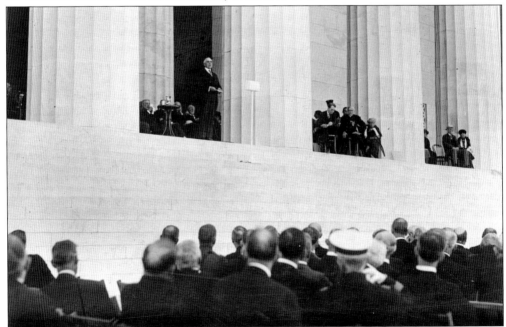

The speeches at the memorial's dedication, attended by Robert Lincoln (by then a former secretary of war), further reinforced this perception of Lincoln. Pres. Warren Harding (shown here speaking) declared, "Lincoln would have been the last man in the republic to resort to arms to effect abolition." (LOC.)

Although Ford's Theatre was repaired after the collapse of 1893, a congressionally appointed board determined in 1894 that various structural deficiencies rendered the building unsafe for further use by government employees. Hence, it was used as a storage facility for government records. In 1912, the building narrowly survived Pres. William Howard Taft's attempt to condemn it and tear it down. (LOC.)

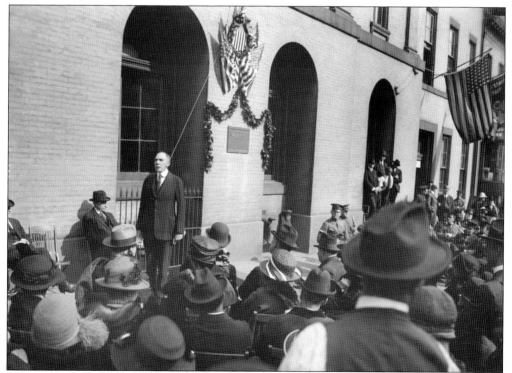

By the 1920s, the building was being used by the Government Printing Office as a warehouse. Despite this underutilization, it gradually began to attract renewed attention with the increased public interest in Lincoln historiography. In this photograph, taken in 1924, Congressman Henry Rathbone is shown at the unveiling of a tablet affixed to the building identifying it as the place where Lincoln was shot. (LOC.)

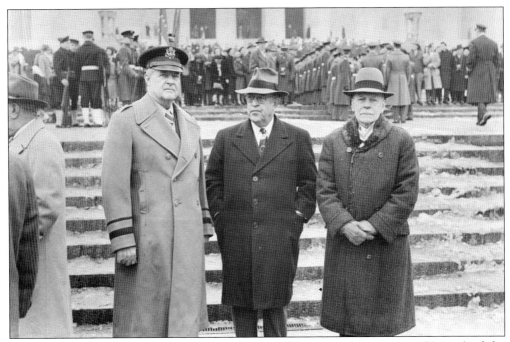

In 1928, the government transferred control of Ford's Theatre and the Petersen House (and the Oldroyd collection contained therein) from the War Department to the Office of Public Buildings and Public Parks of the National Capital. The director of this office was Lt. Col. Ulysses S. Grant III, grandson of the former general and president, standing at left in this photograph. (National Archives & Records Administration.)

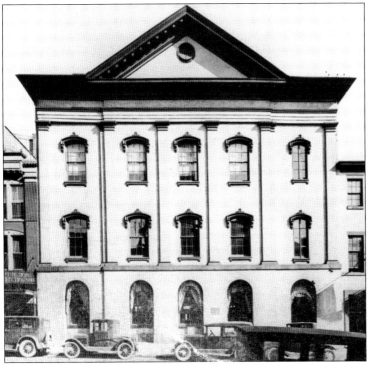

Shortly before his death in 1928, Congressman Rathbone introduced legislation to fund the renovation of Ford's Theatre to serve as a Lincoln museum and library and to house meeting space for veterans' organizations. His bill failed, largely because of sentiment that such a renovation would glorify Lincoln's murderer and that a city that had just built the Lincoln Memorial did not need another one. (NPS.)

Four

1932–1964
Museum

By the time Osborn Oldroyd died in 1930, his collection of Lincoln memorabilia had outgrown the Petersen House. Director of Public Buildings Ulyssen S. Grant III found money in his maintenance budget to move Oldroyd's collection to the first floor of the old Ford's Theatre building, which he dubbed the Lincoln Museum. The museum's exhibits focused on Lincoln's life, presidency, and death. The Petersen House was renovated several times over the next 30 years and was eventually restored in the late 1950s to its appearance on April 14, 1865.

At first, the Lincoln Museum drew little attention, but as the centennial of the Civil War approached and the museum received new artifacts, attendance grew. Still, visitors complained that it was hard to understand the events of the assassination when the building looked nothing like the theater in which Lincoln had been killed. In the 1940s, Sen. Milton Young of North Dakota began a decades-long legislative campaign to restore the building to its appearance on the night of the assassination. Following an intensive study of its history and structure led by National Park Service historian George Olszewski, Congress authorized a $2 million reconstruction based on Mathew Brady's photographs as well as other evidence of the theater's former appearance. Construction began in 1965 and was finished in 1967. The result was the replicated 1865-era Ford's Theatre and facade of the Star Saloon as well as a new Lincoln Museum in the basement. The newly named historic site included the Petersen House across Tenth Street.

The National Park Service's original intention was to use the site to present ranger talks and a sound-and-light show reciting the events of the assassination. Hearing of this plan, Frankie Childers Hewitt, a determined Oklahoman with connections in the political and cultural worlds, believed it both wasteful and disrespectful of Lincoln's love of the performing arts not to produce live theater in the building. With great effort, she persuaded then Secretary of the Interior Stewart Udall to authorize the resumption of live performances in the space. Hewitt created a nonprofit organization named the Ford's Theatre Society to fulfill this mission upon the building's reopening in early 1968.

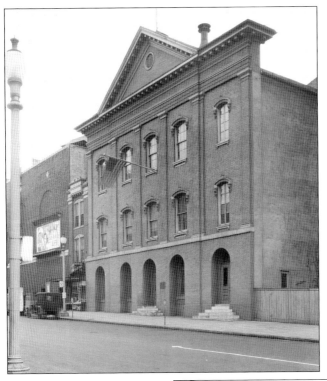

In the early 1930s, as shown at left, the building that once was Ford's Theatre was a quiet, decrepit warehouse with an empty lot in the space where the old Star Saloon building had recently been torn down. In contrast, less than a block away, F Street, shown below in 1936, had become the city's major shopping district. Washington's civic leaders were by this time becoming more aggressive about using spaces around the city to recognize historical events. Seven decades since the Civil War, the emotional responses linking the Ford's Theatre building with the assassination had faded. To some, the time seemed right to use this historic site to memorialize Lincoln. (Left, NPS; below, MLK.)

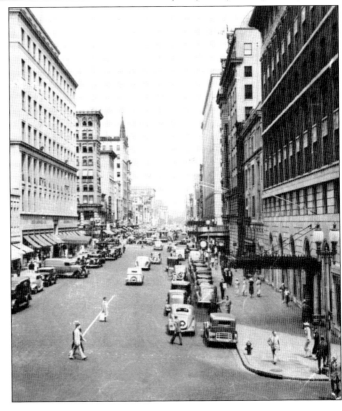

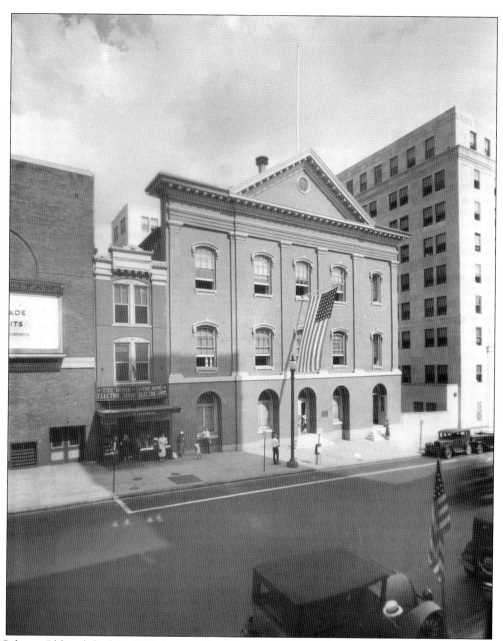

Osborn Oldroyd died in 1930, leaving the Petersen House without a caretaker for the Lincoln memorabilia collection that had now outgrown the building. Lt. Col. Ulysses Grant III, the director of Public Buildings, had supported Congressman Rathbone's campaign to transform the Ford's Theatre building (shown here in 1931) into a museum and veterans' group headquarters. Grant particularly wanted to move the Oldroyd collection across the street to provide better public access and protection from fire. Both Grant and Rathbone expressed reservations about restoring the building to its former use as a theater. Moving the Oldroyd collection also would allow Grant to renovate the Petersen House to make it look more like it did the night Lincoln died. After Congress repeatedly declined to appropriate funds for these purposes, Grant reallocated some maintenance funds from his own budget to perform a modest refurbishment and installation. (NPS.)

The new Lincoln Museum opened in the first floor of the former Ford's Theatre on February 12, 1932 (Lincoln's 123rd birthday). By contrast with the Lincoln Memorial, which focused on President Lincoln's stature as savior of the Union, the Lincoln Museum displayed memorabilia focused more on his human characteristics. (NPS.)

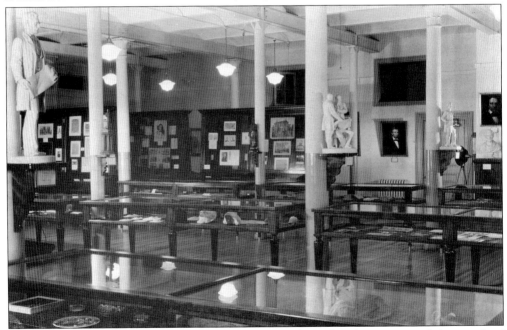

The museum's glass-topped cases, wall-mounted boards, and niches contained thousands of Lincoln-related objects from the Oldroyd collection and other sources. One newly displayed item was a painting made from a sketch created on April 14, 1865, of the dying president being carried across the street to the Petersen House. (NPS.)

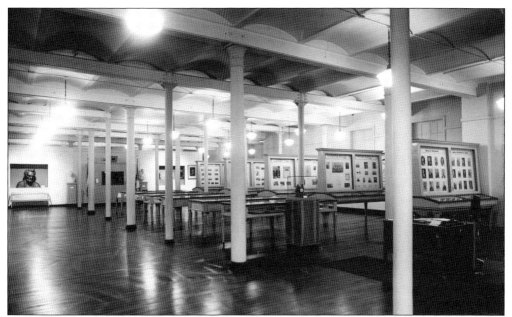

Although transferred to the National Park Service in 1933, the Lincoln Museum suffered from a lack of visitors in its initial years, possibly because of its limitations as a museum. It was in a drab office setting rather than in the theater that occupied the public's imagination, and it initially lacked interesting artifacts about Lincoln. And, as curator John T. Clemens reported, the 10¢ admission charge limited attendance during the Great Depression. (NPS.)

The Lincoln Museum acquired additional artifacts over the years. During the 1930s, members of the Civilian Conservation Corps constructed relief maps and models for the museum to illustrate different events of Lincoln's presidency. Later, the museum received and protected a Civil War–era cannon that was at risk of being melted down for scrap metal during World War II. (NPS.)

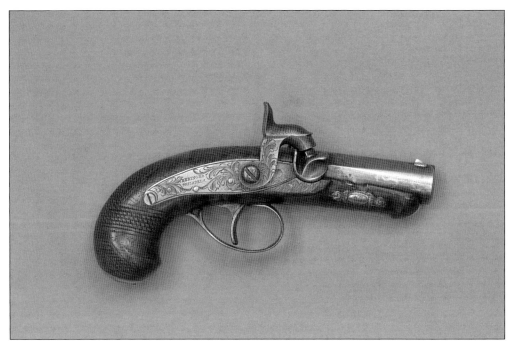

In 1940, the museum obtained from the judge advocate general's office of the War Department the Deringer pistol that John Wilkes Booth used to kill Lincoln (shown above). The museum also acquired *cartes de visite* (visiting cards) that were given to Booth by some of his female admirers and were found in his pockets upon capture, along with Booth's boots, the bar he used to prevent access to President Lincoln's box, and other miscellaneous artifacts from the assassination. In the image below, Edwin B. Pitts, the chief clerk of the judge advocate general, is shown playing with Booth's gun. Modern-day museum practices forbid such antics and require instead minimal, careful handling using gloves. (Above, NPS; below, LOC.)

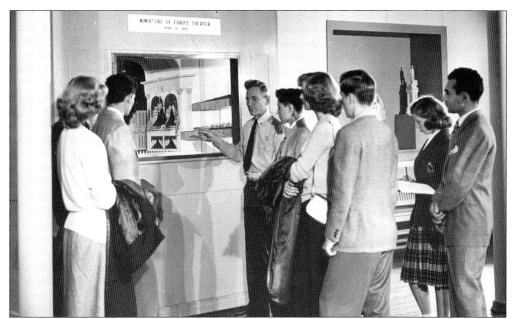

Notwithstanding previously stated concerns that a full restoration of the building as a theater would inappropriately glorify John Wilkes Booth, many visitors expressed disappointment that the museum's layout in a government office building prevented them from understanding where and how the events of April 14, 1865, occurred. Museum management tried to help them by displaying photographs of the theater's interior and drawing black lines on the floor to mark both where the stage and the Presidential Box once stood and the path by which Booth made his escape. The museum also featured dioramas of the theater's interior and of Booth shooting Lincoln, as shown in both images here. (Both, NPS.)

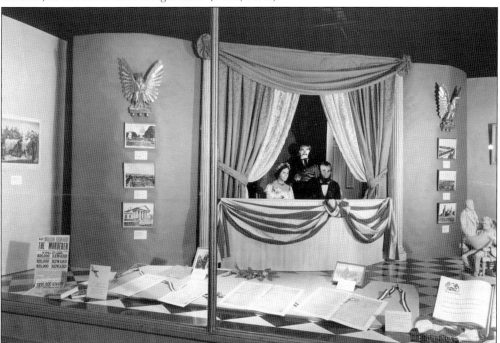

In 1959, John T. Ford's great-grandson Addison Reese (far left) donated several original artifacts from Lincoln's box that had long been in his family: the lithograph portrait of George Washington and the sofa upon which Major Rathbone had sat the night of the assassination. Note the arrows showing the nick on the portrait of Washington and the tear said to have been made in the Treasury flag (given to the museum in 1932) by Booth's spur when he jumped to the stage. The image below shows a park historian pointing to a mark on the frame of the Washington portrait that Booth may have made. The sofa and portrait today occupy the re-created Presidential Box; the original Treasury flag is in the theater's basement museum. (Both, NPS.)

By the 1950s, an information center was installed at Ford's Theatre, and the museum had almost 150,000 visitors per year. The upper floors served as offices for National Park Service staff who answered tourists' questions about Lincoln and his assassination. In the early 1960s, the Lincoln Museum was hosting lectures by noted scholars about Lincoln's life and his presidency. The image below from 1962 shows an address by Civil War scholar Elden E. Billings on "The First Two Years of the Lincoln Administration." (Both, NPS.)

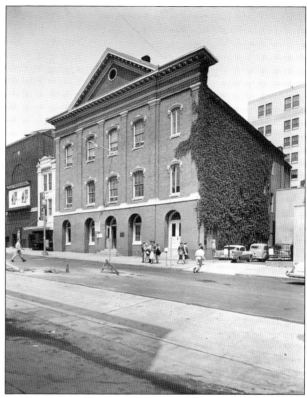

After Oldroyd's Lincoln collection moved out of the Petersen House in 1932, five women's patriotic organizations conducted a partial renovation based on a diagram of the house as it had been shortly after Lincoln's death. Their objective was to make the house look more like the Petersen House of 1865—an example of a middle-class home of the Civil War era. The Interior Department made more repairs to the Petersen House in 1944 and 1945 and later performed a more historically accurate restoration in 1958 and 1959. The above image shows the front parlor after the 1959 restoration. The sofa in the image below came from the Lincoln family home in Springfield and was brought by Oldroyd when he relocated to Washington in the 1890s. (Above, LOC; below, NPS.)

After the 1959 restoration, the room in which Lincoln died contained furnishings similar to those in the room in 1865. A copy of the *Village Blacksmith* replaced the one that had previously hung on the wall, and above the bed was a copy of Rosa Bonheur's *The Horse Fair*. The wallpaper was a reproduction of the original pattern, and the bed and chairs closely resembled those in the room at the time of Lincoln's death. In the picture below, Dorothy Kunhardt, a Lincolniana collector, holds an image of Lincoln's death room that was taken by Petersen House boarder Julius Ulke on the morning of April 15, 1865. (Right, LOC; below, NPS.)

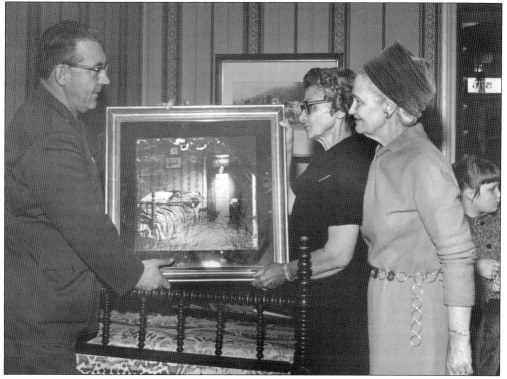

In December 1945, Washington attorney Melvin Hildreth wrote to Sen. Milton Young of North Dakota (pictured above) suggesting that money be appropriated to restore Ford's Theatre to its 1865 appearance. Young, who had visited the Lincoln Museum and been disappointed that its interior bore no resemblance to the historic space, agreed and introduced a resolution directing the secretary of the Interior to estimate the cost of reconstructing the theater. A supporter of Senator Young's bill wrote in a *Washington Post* editorial, "The low-ceilinged room to which the public is admitted . . . is thickly studded with supporting pillars and glass showcases which afford meager material for reconstructing the scene on [April 14, 1865]. Except to the liveliest imagination, the structure is far less suggestive of the playhouse than of Government offices, warehousing and other utilitarian uses to which it has been put. Senator Young's proposal deserves universal and unflagging support." Young's resolution failed, as did another resolution introduced in 1951. Finally, after eight years of lobbying, a third bill was approved and signed by Pres. Dwight Eisenhower in 1954. (NPS.)

In 1960, Congress appropriated $200,000 for the National Park Service to complete preliminary architectural and historical research on the Ford's Theatre building. The project was assigned to George Olszewski, a National Park Service historian and World War II veteran who had attended a performance at John T. Ford's Baltimore theater as a child. Olszewski, working out of his National Park Service office in the former Ford's Theatre building, undertook comprehensive and meticulous research to determine the structure's 1865 appearance from, among other things, Mathew Brady's post-assassination photographs. In 1962, he published the 138-page *Historic Structures Report* that described the building's history and included blueprints for its renovation. The publication would serve as a road map for the future restoration of the site. (Both, NPS.)

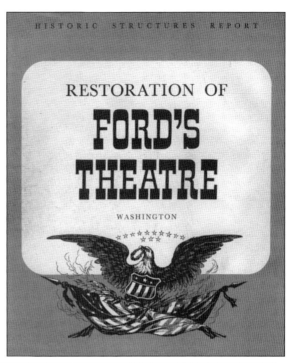

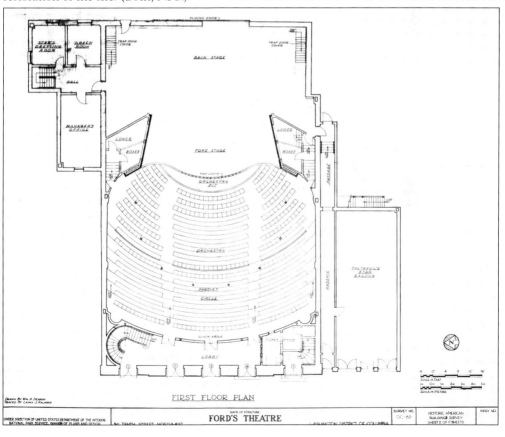

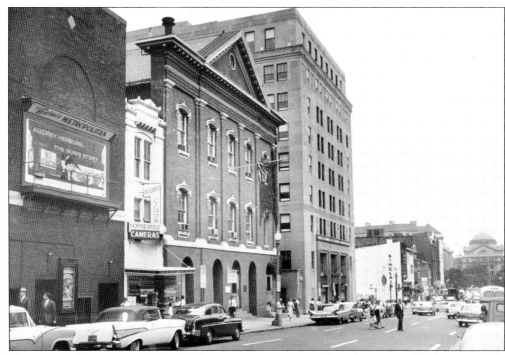

The proposed restoration of Ford's Theatre came at a time when downtown Washington, DC, was deteriorating. Although the center of action from the 1830s through the 1930s, downtown Washington began a gradual decline in the 1940s as people moved from the central city to the far regions of the District of Columbia and the Maryland and Virginia suburbs. Businesses followed them, relocating to malls and abandoning downtown to small-time retailers and empty storefronts. Driving down a decrepit Pennsylvania Avenue during his 1961 inaugural parade, Pres. John F. Kennedy was appalled by the shoddy condition of "America's Main Street" and appointed then assistant secretary of labor (and later US senator) Daniel Patrick Moynihan to develop a plan to rejuvenate the downtown. (Both, MLK.)

To build public support for the restoration of the theater, Olszewski mounted an international press campaign in newspapers and magazines as well as on the radio. It worked. Citizens wrote their congressmen asking them to appropriate money to rebuild the theater and sent in donations themselves. President Kennedy's assassination in 1963 created renewed interest in Lincoln's shooting and support for restoring the place where it occurred. On July 7, 1964, Congress appropriated $2 million to restore the site. The lead architect was Charles Lessig, shown here. Lessig had previously worked on the restoration of several other Civil War–related historic sites, including the Custis-Lee Mansion overlooking Arlington National Cemetery, the McLean House in Appomattox (where General Lee surrendered), and several sites in Gettysburg. (NPS.)

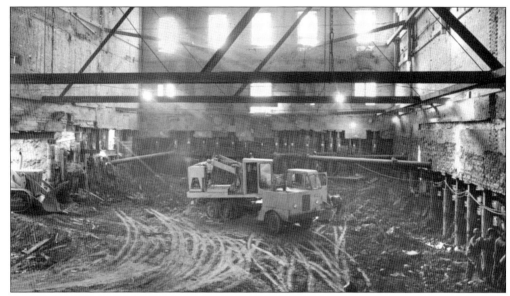

The Ford's Theatre building housing the Lincoln Museum was closed to the public on November 29, 1964, and renovation began in January 1965. The interior of the building was completely gutted, the basement excavated, and the exterior walls reinforced. Olszewski remained a constant presence throughout the project, ensuring the historical accuracy of the construction and photographing all its stages. (NPS.)

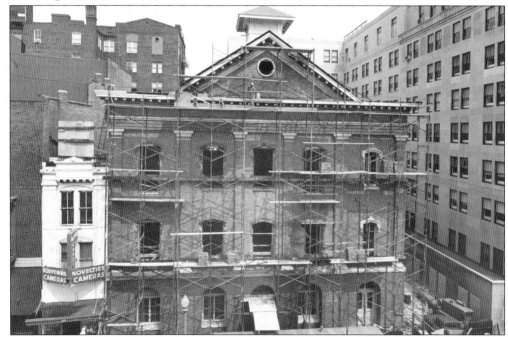

The restoration was meant to duplicate the 1865-era theater in appearance while meeting modern safety and engineering standards. This image shows the scaffolding in front of the building, where workers reduced the windows' size (which had been expanded to provide more light for late-19th-century government workers) to that of 1865. The fill-in brickwork around the front windows from this project is still visible today. (NPS.)

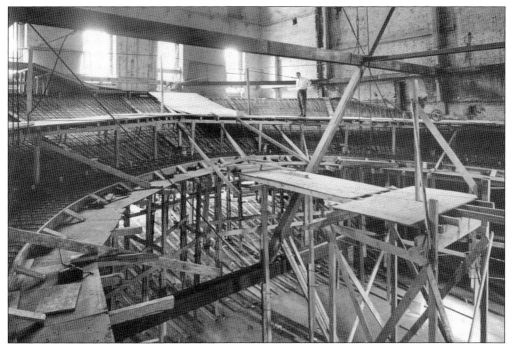

Builders used Olszewski's report, which included newly drawn blueprints of the 1865-era structure and drawings of building details—such as window and door framing, columns, and molding—to construct a replica of the theater, albeit with modern facilities expected of a 20th-century performing-arts establishment. The image above, looking toward the front of the theater, shows the structure for the Dress and Family Circles. The image below, taken later, shows the stage in the foreground, two of the stage-left boxes (including the Presidential Box), and part of the Orchestra and Dress Circle seating areas. (Both, NPS.)

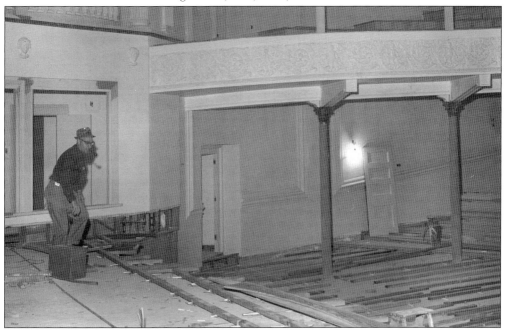

As part of the effort to ensure historic accuracy, the restorers replicated 1860s-era backstage rigging featuring a complex system of ropes and pulleys to manually raise and lower backdrops. This proved cumbersome to 20th-century stagehands, so a state-of-the-art, automated rigging system was installed later to meet current technological needs and safety standards. (NPS.)

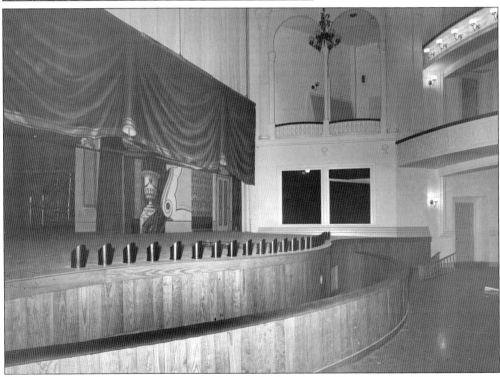

Workers restored the stage and boxes (including the Presidential Box) to their 1865 appearance. For the anticipated 1968 reopening of the theater, designers reproduced the set of *Our American Cousin*, the play that was being performed the night Lincoln was shot. While this backdrop proved useful for National Park Service programming about the circumstances of Lincoln's assassination, that play has not been performed at the renovated Ford's Theatre. (NPS.)

The National Park Service renovation project included a partial reconstruction of the Star Saloon. Although its front exterior was built to reflect its appearance in 1865, the interior contained, instead of a bar, a box office for the theater on the first floor and offices and conference rooms for National Park Service staff on the upper two floors. (NPS.)

The renovation was finished in late 1967. This image shows the completed front of the theater and Star Saloon, including such historically accurate details as the sign pointing to the Family Circle entrance and providing the historical price of 25¢. (The Family Circle is no longer used for patron seating but instead houses the stage management booth and theatrical lighting equipment.) (NPS.)

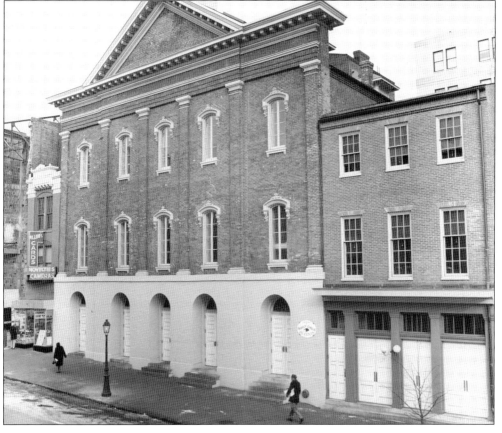

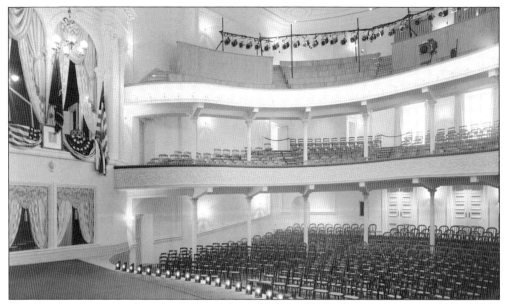

The above image was taken from stage right and shows the Orchestra and Dress Circle levels. The freestanding wooden chairs, evocative of the 1860s, proved to be too uncomfortable for 20th-century patrons. The boxes—consistent with original design—faced away from the stage and toward the audience, making them undesirable for theatrical viewing; hence, they were not made available for patron seating. While the flags draping the box are reproductions, the framed engraving of George Washington mounted to the balcony during the renovation is original. The image below, taken from the Orchestra level, shows the orchestra pit in front of the stage as well as the doors leading to the two stage-left boxes. (Both, LOC.)

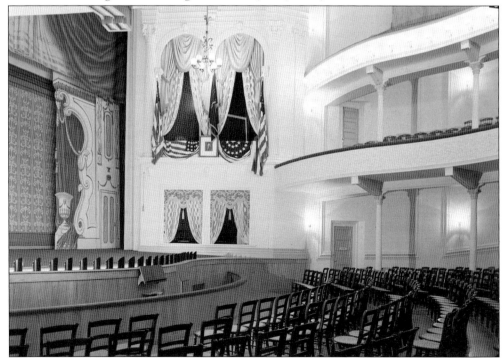

The image at right shows the interior of the Presidential Box, renovated to its appearance on April 14, 1865. While the sofa is original, all other furnishings in the box are historically accurate duplicates. The actual chair in which Lincoln sat (shown below) was sold by Ford family members and eventually acquired by the Henry Ford Museum in Dearborn, Michigan, where it is on display today. The stain near the top of the chair is not Lincoln's blood (he bled very little while still seated). Instead, it is hair oil from the many people who were allowed to sit in it after Lincoln died. The worn-out fabric is, likewise, the result of post-assassination usage. Such handling of a valuable historical artifact is a relic of an earlier, more permissive approach to historic preservation. (Right, photograph by Carol M. Highsmith, NPS; below, LOC.)

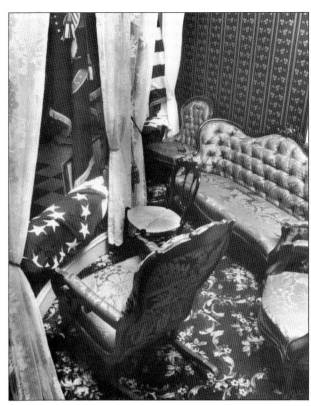

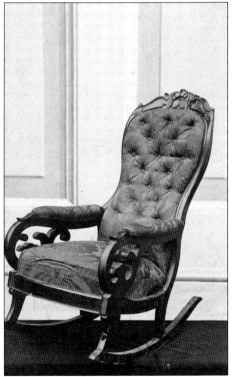

The artifacts of the former first-floor Lincoln Museum were moved to a new museum in the basement of the renovated theater. The museum had a circular setup; artifacts and images from Lincoln's life and assassination were displayed along with wax figures on the outside walls, leading to the center display of Lincoln's life mask. Responding to long-standing concerns that the renovation would glorify the murder in a decade marked to that point by the 1963 Kennedy assassination, the 1968 museum focused on Lincoln's life and de-emphasized the events of his killing, barely mentioning the fate of Booth and his conspirators or public reaction to Lincoln's death. (Both, NPS.)

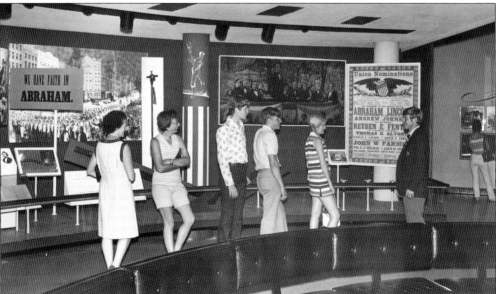

The Lincoln Museum contained artifacts from the Oldroyd collection plus many new items obtained over the years. A centerpiece of the museum was a life-mask cast of Lincoln's face in 1860. The museum also obtained the overcoat Lincoln wore the night of his assassination, which Mary Todd Lincoln had given to the White House doorkeeper after her husband's death. In 1967, one of the doorkeeper's descendants sold the coat to a private organization that donated it to the National Park Service museum. Lincoln's coat today is in fragile condition and so is kept in long-term storage for its protection. (Right, NPS; below, FTS.)

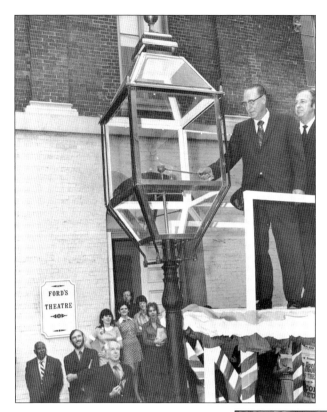

The final piece of the Ford's Theatre restoration was the reconstruction of the open-flame gas lantern that stood outside the building in the 1860s. On September 24, 1971, Senator Young, who had lobbied so long to restore the theater, was given the honor of lighting the lantern. (NPS.)

Stewart Udall, shown walking to the left of poet Robert Frost, was a key figure in the restoration of Ford's Theatre. Udall was a congressman until President Kennedy appointed him secretary of the Interior, overseeing the National Park Service. Secretary Udall held this post until the end of the Johnson administration and achieved the enactment of environmental preservation laws and the creation and renovation of national parks and historic sites, including Ford's Theatre. (Udall estate.)

A meeting between Secretary Udall and Frankie Childers Hewitt (shown here in the 1970s) would have a profound effect on Ford's Theatre. Hewitt, the daughter of refugees from the Oklahoma Dust Bowl, grew up in California. After moving to Washington, DC, in the 1950s, she became staff director of a Senate committee and then a public affairs advisor to United Nations ambassador Adlai Stevenson during the Kennedy administration. Married to *60 Minutes* producer Don Hewitt, Frankie Hewitt, by the mid-1960s, had strong connections in both the political and media worlds. In 1965, Secretary Udall told Hewitt that Ford's Theatre was being restored. When Hewitt asked if live theater would be presented in the building, Udall said, "No, the government can't run a theater." Hewitt opined that not presenting live theater at Ford's Theatre would constitute "building a monument to John Wilkes Booth." Hewitt later introduced Udall to the director of the National Repertory Theatre, who convinced Udall to permit live theatrical productions on the Ford's Theatre stage. (Cassara.)

Realizing she needed to start a nonprofit entity to present theatrical productions at Ford's, Hewitt enlisted President Kennedy's former speechwriter Ted Sorensen, an attorney, to draw up the legal papers creating the Ford's Theatre Society and negotiate an agreement with the National Park Service to produce shows at the venue. Frankie Hewitt's husband suggested raising money for the new theatrical productions by soliciting corporate sponsorship of a televised broadcast of the opening-night performance. The Lincoln National Life Insurance Company expressed tentative willingness to provide the financing, but its chief executive sought White House support before committing. Using her political connections, Hewitt introduced the company official to the first lady, Lady Bird Johnson (shown here with Hewitt), whose endorsement secured the necessary financing. (Cassara.)

Five

1968–Today
Theater, Museum, and Education Center

On January 30, 1968, professional performers appeared at Ford's Theatre for the first time since Lincoln's assassination 103 years earlier. The nationally televised reopening featured some of the nation's leading artists. Thereafter, the National Park Service and Ford's Theatre Society carried out their separate but connected missions to use the historic site to educate visitors about Abraham Lincoln's life, death, and legacy.

The National Park Service presented ranger and expert talks and a sound-and-light show about Lincoln's assassination and oversaw exhibits in the basement of the theater. Ford's Theatre Society, sometimes partnering with other organizations and sometimes functioning independently, presented plays and musicals illustrating aspects of American culture, chosen to reflect Lincoln's values and appeal to multiethnic and multigenerational audiences.

Frankie Hewitt, the Ford Theatre Society's leader, took advantage of the site's historic importance when encouraging political figures and corporate leaders to support the theater's annual televised fundraising galas. These events allowed the society to raise money while providing a venue for the nation's leaders to set aside their partisan differences and, in the spirit of Lincoln, enjoy evenings together celebrating the arts and the nation's history.

Hewitt's death in 2003 coincided with a rebirth of downtown Washington as new residential and entertainment offerings revived the neighborhood now called Penn Quarter. Seeking to increase the relevance of Ford's Theatre as a monument of American history, Ford's Theatre Society appointed Paul R. Tetreault as Hewitt's successor, with a mandate to maximize the site's ability to educate visitors about Lincoln as a human being and his impact on American history. Theatrical productions focused on illustrating different eras and themes of the American experience and the values that developed the nation.

As a result of a $55 million capital campaign spearheaded by board chair Wayne R. Reynolds and campaign chair Rex W. Tillerson, the theater was renovated yet again from 2007 to 2009. The basement museum was reimagined to interpret the whole of Lincoln's presidency, and the new Center for Education and Leadership opened in 2012 across the street to house the society's expanded exhibitions and programming. Today, Ford's Theatre and its associated Tenth Street campus is the premier venue for teaching the world about Abraham Lincoln's legacy.

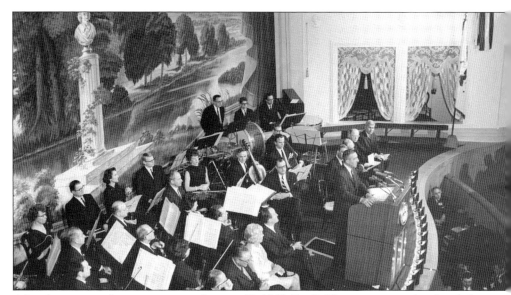

After three years of construction, on January 21, 1968, Ford's Theatre reopened with a dedication ceremony hosted by Secretary of the Interior Stewart Udall, shown speaking above. During the ceremony, Sen. Milton Young (who sponsored the bills leading to the renovation) spoke about the 22-year effort to reach that day; Sen. Charles Percy from Illinois read a selection of Lincoln's memorable quotes; and Vice Pres. Hubert Humphrey spoke about the theater's symbolism noting, "This theatre will do much not only to recall the growing pains of our democracy . . . but because it will be a living theatre it will do much to bring us even greater days." Afterward, Vice President Humphrey, shown below, and other attendees toured the new Lincoln Museum in the theater's basement. (Both, NPS.)

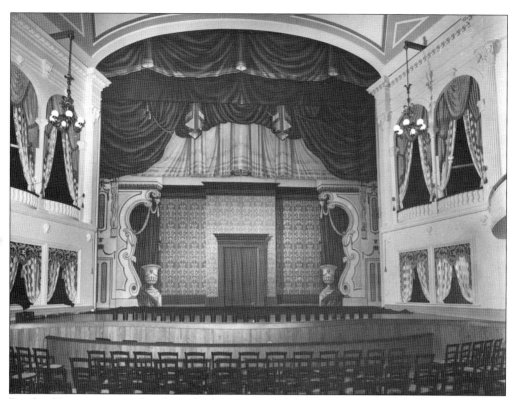

Frankie Hewitt, entrusted with producing the first entertainment performed at Ford's Theatre since Lincoln's assassination, chose a program of live performances, rather than prepackaged films and speeches, in order to set the precedent that the building would operate as a working theater. On January 30, 1968, with the stage exhibiting the scenery of *Our American Cousin* (shown above), renowned stage actress Helen Hayes (shown at right) began the Ford's Theatre grand reopening performance by reading a portion of that play as the Presidential Box was lit. She was the first person to perform at Ford's Theatre since the play was halted mid-performance on April 14, 1865. Hosted by Lady Bird Johnson, this televised event also included Henry Fonda, Harry Belafonte, and Andy Williams. (Above, NPS; right, FTS.)

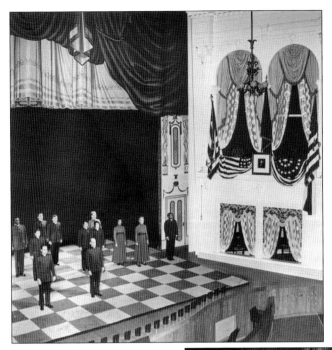

Ford's Theatre Society contracted with National Repertory Theatre to produce the first season of shows. On February 12, 1968, Lincoln's 158th birthday, Ford's reopened with Steven Vincent Benet's *John Brown's Body*, which used poetry and music to illustrate the Civil War's effect on the lives of ordinary people. The show ran for one month. (NPS.)

For the 1969–1971 seasons, the society contracted with the Circle in the Square theater in New York City to present programming at Ford's, which introduced *Will Rogers' USA*, starring James Whitmore. Whitmore became a Ford's mainstay—performing this show for eight separate engagements from 1970 to 2000, portraying Harry Truman in *Give 'Em Hell, Harry!* in 1975, appearing in *All I Really Need to Know I Learned in Kindergarten* in 1997, and playing Franklin Delano Roosevelt's attorney general, Francis Biddle, in *Trying* in 2006. (FTS.)

98

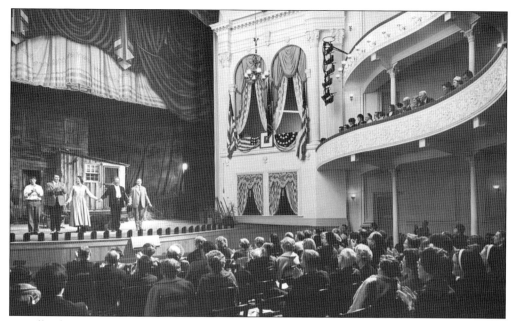

Initially, the National Park Service wanted the society to only present "works that played or could have played" between 1863 and 1865—a requirement that proved commercially impractical, as suggested by the empty seats at this 1970 performance. In 1971, Frankie Hewitt became the society's producing director and began independently mounting shows that appealed to diverse audiences and illustrated the qualities embodied by President Lincoln. (NPS.)

In April 1972, Ford's opened *Godspell*, a musical based on the Gospel of Matthew that would run until September 1973, making it the longest-running production in Ford's Theatre's history. The show featured modern music set to the lyrics of traditional religious hymns and was revived more than once on Broadway. Here, Anne Morton greets cast members as her husband, Secretary of the Interior Rogers Morton, and Frankie Hewitt look on. (Cassara.)

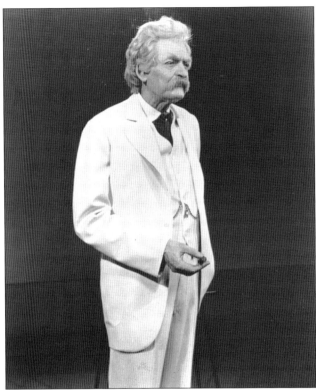

In 1972, noted actor Hal Holbrook brought his one-man show, *Mark Twain Tonight*, to Ford's Theatre. Drawing upon Twain's many writings, Holbrook's show was a humorous monologue in which he portrayed Twain commenting on various aspects of American politics and culture. As of 2013, Holbrook had performed the show, in various theaters, 59 years in a row. (FTS.)

In 1975, Ford's Theatre Society produced and premiered *Your Arms Too Short to Box with God*, a musical based on the book of Matthew. After seven months at Ford's, the show went on to run on Broadway. This photograph shows Frankie Hewitt and the cast. (Photograph by Milton Williams; Cassara.)

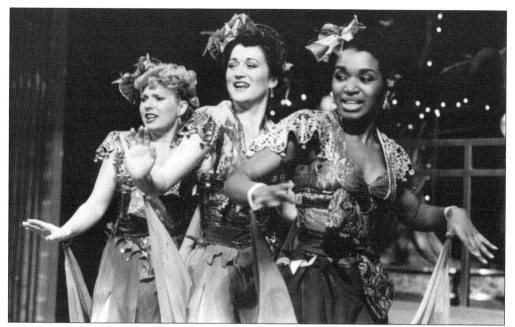

In 1986, the theater's artistic director, David Bell, wrote, directed, and choreographed *Hot Mikado*, a musical comedy based on Gilbert and Sullivan's *The Mikado*. The show returned to Ford's in 1994 and 2002 and continues to be presented at theaters around the world. This photograph shows, from left to right, Robin Baxter, Kathleen Mahoney-Bennett, and Val Scott. (FTS.)

In 1988, to celebrate the 20th anniversary of its reopening, Ford's premiered *Elmer Gantry*, a musical about an evangelistic swindler, based on Sinclair Lewis's novel of the same name. The show received rave reviews and returned for a second run in 1995. Here, lead actors John Dossett and Sharon Scruggs are shown in rehearsal for the 1995 production with director Michael Maggio (right). (FTS.)

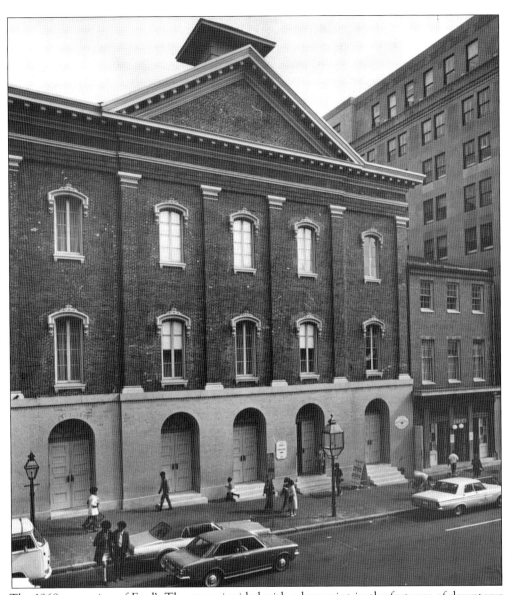

The 1968 reopening of Ford's Theatre coincided with a low point in the fortunes of downtown Washington. Residents and businesses had been abandoning the city for the suburbs for years, and the riots following Dr. Martin Luther King's April 1968 assassination further discouraged tourism and commerce in the downtown area. Still, the National Park Service and Ford's Theatre Society persevered in their efforts to promote the historic site. In 1970, Congress created the Ford's Theatre National Historic Site, consisting of Ford's Theatre, the adjacent Star Saloon building to the south, the adjacent three-story building to the north, and the Petersen House. The National Park Service maintained the buildings and the artifacts within and presented educational programming. Today, more than 650,000 people visit Ford's Theatre every year, making it one of the most visited sites in the nation's capital. (NPS.)

National Park Service rangers gave tours of the theater and talks about Lincoln's life, presidency, and assassination. The National Park Service organized periodic conferences at the theater, inviting Lincoln scholars and others to discuss different aspects of his legacy. Here, a 1970s-era uniformed park ranger gives a talk in the theater to a group of visitors. (NPS.)

Here, a National Park ranger is showing young visitors the array of weapons used by Booth and his coconspirators. In 1971, when this picture was taken, female park rangers wore uniforms more closely resembling those of flight attendants than what today is considered the traditional ranger uniform. (NPS.)

In 1970, the National Park Service presented a new 30-minute sound-and-light show to tell the story of President Lincoln's assassination. Seated in the audience and facing the set of *Our American Cousin*, patrons equipped with headsets listened to a performance narrated by James Earl Jones and featuring Lee J. Cobb as Lincoln and Stacy Keach as Booth while 153 lights illuminated different sections of the theater relevant to the story. Sound-and-light shows were considered cutting-edge in the 1970s, and this was the first one presented indoors. The shows were performed four times a day, seven days a week for several years. Here, rangers in costume answer questions. (Both, NPS.)

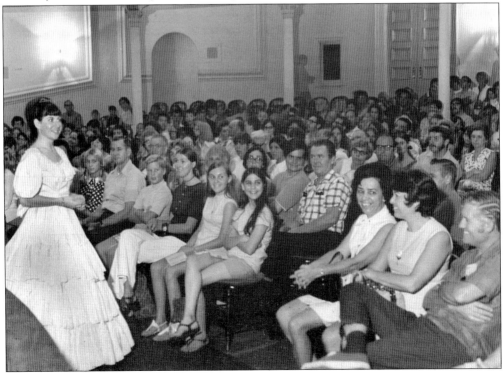

The National Park Service designed the basement Lincoln Museum to emphasize Lincoln's life and presidency rather than the circumstances of his death. The service did not want the assassination to detract from educating people about Lincoln and felt his assassination could be addressed at the Petersen House. However, over time, it became clear that visitors wanted to learn about the assassination and see artifacts of it. In 1988, the National Park Service renovated the museum. When reopened in 1990, it illustrated various aspects of Lincoln's presidency while also containing items from the assassination, including the coat Lincoln wore to the theater, the door to the Presidential Box, Booth's gun, a fragment of the bullet that killed Lincoln, and memorabilia of Booth's coconspirators. (Above, photograph by Carol M. Highsmith, LOC; below, FTS.)

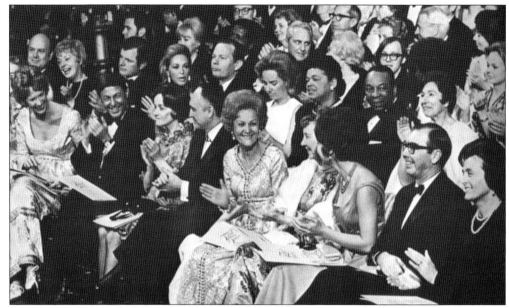

Hewitt's strategy for improving Ford's visibility and financial health involved presenting events that would bring top political figures to the theater, thus encouraging attendance by lobbyists, who valued the chance to mingle with government leaders in a social setting. Ford's Theatre Society's annual galas typically involved a variety-show format and featured entertainers from stage, film, and television. For many years, the event was broadcast on network television. The first gala was held in 1970 and was attended by First Lady Patricia Nixon and former first lady Mamie Eisenhower, shown in the center of the above image. Below, the second gala, in 1971, featured, from left to right, Raymond Burr, Pat Boone, Charley Pride, Carol Channing, Henry Mancini, and Jonathan Winters. (Above, Cassara; below, FTS.)

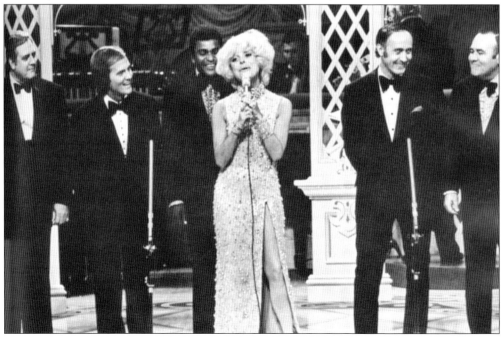

Gerald Ford became the first president since Abraham Lincoln to visit Ford's Theatre when, on April 17, 1975, he attended *Give 'Em Hell Harry*. Ford remarked afterwards, "I'm learning a lot of other good reasons why I thought [Harry Truman] was a good man." The Fords also hosted a White House party in 1976 for the performers in *The All Night Strut*, which included First Lady Betty Ford leading a conga line. (Cassara.)

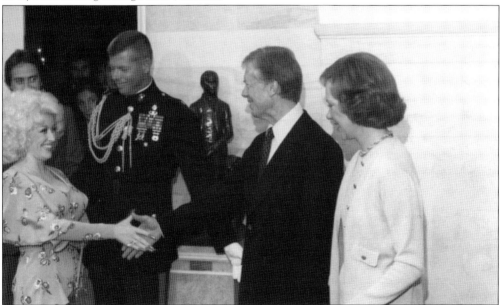

In 1979, Pres. Jimmy Carter and First Lady Rosalynn Carter hosted a White House reception before the televised Ford's Theatre gala, "A Celebration of Country Music," which featured such stars as Johnny Cash, the Statler Brothers, Roy Clark, and Tammy Wynette. Here, the Carters greet Dolly Parton at a White House reception before the show. (Cassara.)

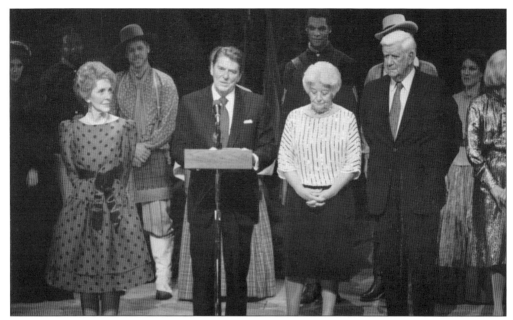

There were seven gala performances during Pres. Ronald Reagan's tenure. Usually, they were variety shows that included numbers from then running musicals at Ford's. Here, Reagan is shown giving remarks at the conclusion of a performance, a practice that has become customary. Also shown are, from left to right, First Lady Nancy Reagan, Mildred O'Neill, and House Speaker Thomas P. O'Neill Jr. (Cassara.)

During Pres. George H.W. Bush's term, Ford's Theatre Society presented a variety-show gala in 1990, a "Celebration of Country" gala in 1991, and a "Saluting Our Hispanic Heritage" gala in 1992. Here, Bush is shown addressing the audience at the end of the 1992 gala as First Lady Barbara Bush and actor John Forsythe look on. (Cassara.)

There were six galas during Pres. Bill Clinton's tenure, including one in which illusionist David Copperfield called First Lady Hillary Rodham Clinton up from the audience to assist with his act. Other gala performers during this era included Nathan Lane, Whoopi Goldberg, Kevin Spacey, Gregory Hines, and Paula Poundstone. (FTS.)

Pres. George W. Bush and First Lady Laura Bush are shown with then Walt Disney Company chief executive officer Michael Eisner and his successor, Robert Iger (far left). The Bushes attended galas annually and hosted several White House events in honor of Abraham Lincoln and Ford's Theatre. In November 2008, President Bush awarded Ford's Theatre Society the National Medal of the Arts for its contributions to the creation, growth, and support of the arts in the United States. (FTS.)

Frankie Hewitt spent half her life running Ford's Theatre Society. Over the course of 35 years, she took the organization from infancy to a position where, working with the National Park Service, it helped Ford's Theatre became one of the most popular tourist and theater destinations in Washington, DC. In so doing, she helped settle the long-debated questions about how to use the site of this national tragedy to teach visitors about Abraham Lincoln's life, rather than glorify the circumstances of his death. The secret of her success was that she encouraged Ford's Theatre patrons and supporters to check their partisanship and ideology at the door and experience the historic place together as Americans. Frankie Hewitt died on February 28, 2003. A few days before her death, President Bush awarded her the National Humanities Medal in recognition of her success in restoring Ford's Theatre as an important national center for the humanities. (FTS.)

Following a nationwide search, Paul R. Tetreault was hired as the society's producing director in 2004. Tetreault, who had previously led the Alley Theatre in Houston, arrived with a mission to ensure high quality and thematic consistency in Ford's theatrical presentations, develop additional ways to use the historic site to educate visitors about Lincoln's character and legacy, and manage physical improvements to the theater and related venues. (Photograph by Scott Suchman.)

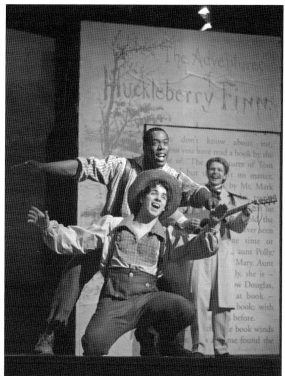

Today, Ford's Theatre Society presents four shows each season that explore different aspects of the American experience. One of Tetreault's first productions, *Big River: The Adventures of Huckleberry Finn*, addressed race and physical disability by using deaf actors—accompanied by interpreters and musicians—to tell Mark Twain's story of race relations before the Civil War. This photograph shows, from left to right, Christopher Corrigan, Michael McElroy, and Bill O'Brien. (Photograph by T. Charles Erickson.)

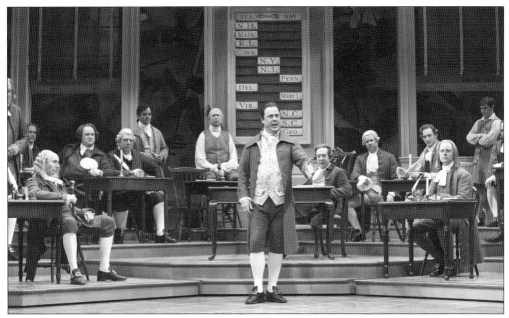

A recurring theme of Ford's Theatre productions is an exploration of the factors that influence political leaders' decisions. The musical *1776*, which tells how the delegates to the Continental Congress overcame their regional differences to reach agreement on the Declaration of Independence, played to packed houses in 2003 and again in 2012. *Meet John Doe*, based on the 1941 Frank Capra film, addresses how hidden forces (here, business interests and the media) sometimes lie behind seemingly spontaneous and well-intentioned political movements. The photograph above shows the company of the 2012 production of *1776*; the photograph below shows the cast of *Meet John Doe*. (Above, photograph by Carol Rosegg; below, photograph by T. Charles Erickson.)

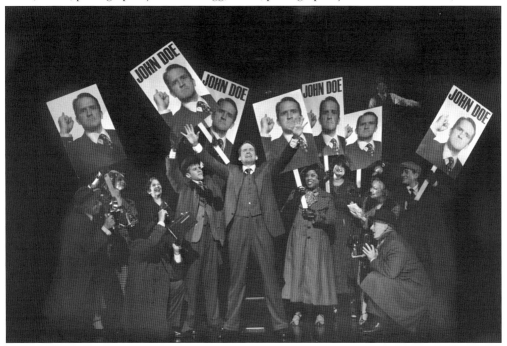

Ford's Theatre has both commissioned and produced plays featuring Abraham Lincoln as the central character, allowing patrons to see his personal qualities and appreciate the challenges he confronted. Several different actors have portrayed Lincoln at Ford's Theatre over the years. David Selby assumed the role in 2009 for *The Heavens Are Hung in Black*, which showed the personal and political challenges Lincoln faced in 1862 after the death of his son Willie while he considered issuing the Emancipation Proclamation. Selby returned to Ford's in 2012 in *Necessary Sacrifices*, which explored the two known White House encounters between Lincoln and abolitionist Frederick Douglass, played by Craig Wallace. These photographs show David Selby with Benjamin Cook (right, as Tad Lincoln) and Craig Wallace (below). (Both, photograph by T. Charles Erickson.)

In 1979, Ford's began a near annual tradition of presenting Charles Dickens's *A Christmas Carol* to large audiences during the holiday season. This classic tale of transformation and redemption is periodically refreshed with new interpretations, sets, and costumes. This photograph shows Edward Gero as Ebenezer Scrooge (foreground) and James Konicek as Jacob Marley. (Photograph by Scott Suchman.)

In 2011, Ford's began The Lincoln Legacy Project, which used theatrical productions, educational forums, and social events to promote dialogue about tolerance, equality, and acceptance. The project began with a focus on anti-Semitism through the musical *Parade* and next considered racial prejudice through *Fly*. The third year addressed prejudice based on sexual orientation in *The Laramie Project*. Here, the cast of *Fly* is joined onstage by Tuskegee Airmen following the opening performance. (Photograph by Gary Erskine; FTS.)

Ford's Theatre Society employs creative strategies to use performance to educate and entertain. In 2007, Ford's launched *One Destiny* (shown above)—a 35-minute play presented every spring and summer that revisits the key events of Lincoln's assassination and explores the emotions it evoked. Pictured are actors Michael Bunce (left) and Stephen F. Schmidt. Ford's also offers *History on Foot* walking tours in which a costumed actor leads participants on an educational walk through downtown Washington. In the image below, William Diggle portrays Det. James McDevitt leading a tour of key sites related to the conspiracy to kill Lincoln and other top government officials in *Investigation: Detective McDevitt*. (Both, photograph by Gary Erskine; FTS.)

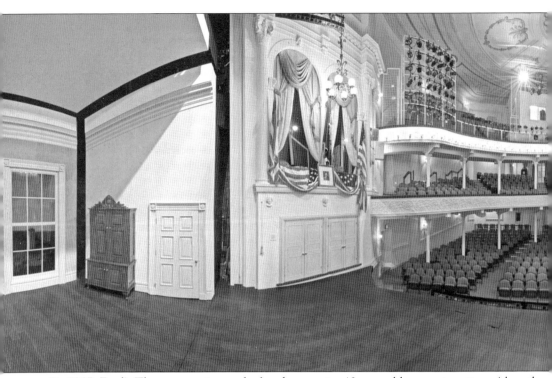

By 2007, Ford's Theatre was in need of updates to its 40-year-old reconstruction. Also, the time had come to use the building to more effectively tell an expanded Lincoln story. Through a capital campaign launched by Ford's Theatre Society chairman Wayne R. Reynolds and campaign chairman Rex W. Tillerson, the society partnered with the National Park Service to implement a series of major renovations, improvements, and expansions between 2007 and 2009.

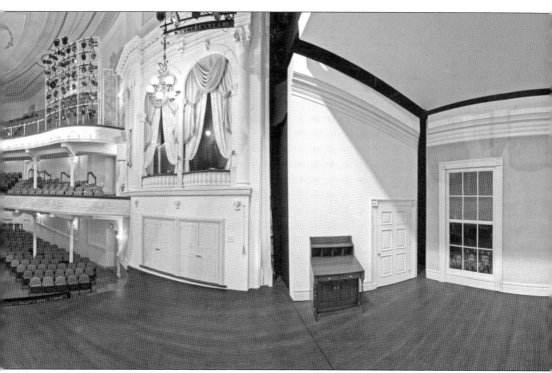

The theater received new sound, lighting, stage-rigging, and ventilation systems, including 658 upholstered seats to replace the uncomfortable wooden chairs that had been meant to echo the original theater seating. The result is a historically accurate representation of the 1865 theater with the modern equipment and amenities expected of a 21st-century theater. (Photograph © Maxwell Macknezie.)

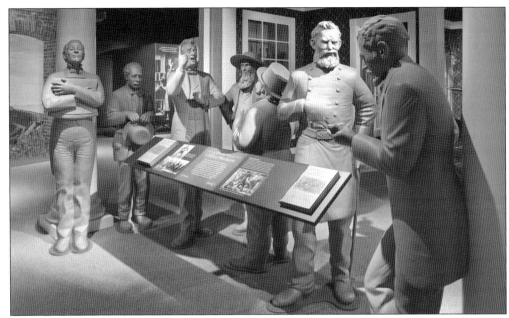

The renovation reconceived the basement Lincoln Museum to meet contemporary visitor expectations for visually interesting multimedia presentations. The new museum was organized chronologically, describing the conflict Lincoln faced when he took office, his management of the four-year war effort, other aspects of his presidency, and the conspiracy to kill him. A highlight of the museum is a video of four recent presidents collectively reciting the words of Lincoln's Gettysburg Address. Visitors proceed from the museum to the theater through a hallway containing a timeline of the events of April 14, 1865. In the theater, they can attend a ranger talk or an interpretive performance, then visit the Petersen House across the street, and conclude with a visit to the museum galleries located in the Ford's Theatre Society Center for Education and Leadership. (Both, photograph © Maxwell MacKenzie.)

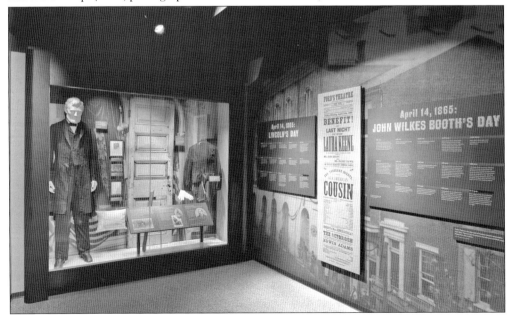

For decades, Ford's Theatre was confined to its historic structure and therefore lacked the amenities expected by modern visitors and performers. Using street-level space acquired in an adjacent office building, the society built a modern lobby containing a box office, gift shop, expanded backstage space for performers, and an elevator down to a parking garage and up to each level of the theater. This replaced the narrow hallway at the front of the theater that had previously served as its lobby and the box office formerly located on the first floor of the recreated Star Saloon. The above image shows part of the new lobby; the image below shows the outside of the theater complex, with new signage making it easily visible to passersby. (Above, photograph by Carolina Dulcey, FTS; below, photograph by Gary Erskine, FTS.)

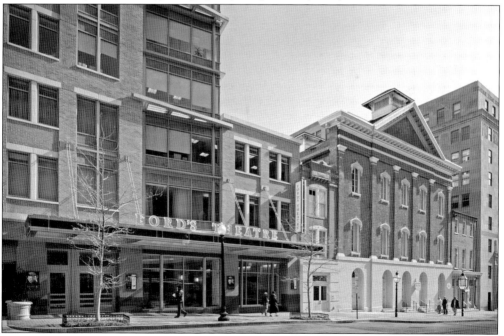

The renovated theater reopened on February 11, 2009—the night before President Lincoln's 200th birthday—at an event attended by Pres. Barack Obama and First Lady Michelle Obama and featuring performances by, from left to right, Katie Couric, James Earl Jones, Ben Vereen, Jessye Norman, Audra McDonald, and others. Actor David Selby, portraying Lincoln, presented President Obama with a copy of the Gettysburg Address 20 feet from where the Civil War president was assassinated. (Photograph by Reflections Photography.)

This most recent renovation of Ford's Theatre was a fitting capstone to downtown Washington's gradual reemergence from its low point in the 1960s. The Penn Quarter neighborhood surrounding Ford's Theatre is once again a residential, commercial, and entertainment center of Washington, DC. The streets are filled day and night with workers, shoppers, residents, and tourists, all enjoying a revitalized downtown. (Photograph by Gary Erskine; FTS.)

Another objective of the Ford's Theatre Society capital campaign was to create a place to educate visitors—both on-site and virtually—about Abraham Lincoln's presidency and legacy. To do this, the society purchased a 10-story building next to the Petersen House. In 2010, it was renovated to create office, programming, and museum space to tell the story of Lincoln's funeral, the capture and prosecution of his killers, and his evolving legacy. The Ford's Theatre Center for Education and Leadership supports a staff that develops innovative programming to teach the lessons of Lincoln's persona and presidency to people across the country. Below, from left to right, society board chair Wayne R. Reynolds; his successor, Eric A. Spiegel; DC councilman Jack Evans; and Paul R. Tetreault are shown at the ribbon-cutting ceremony for the Center for Education and Leadership in February 2012. (Right, photograph © Maxwell MacKenzie; below, photograph by Reflections Photography.)

One gallery at the Center for Education and Leadership focuses on the aftermath of the Lincoln assassination. It contains a re-creation of the Lincoln funeral train as it traveled from Washington to Springfield, Illinois, and exhibits describing the hunt for John Wilkes Booth and his coconspirators, their capture, and their prosecution. (Photograph © Maxwell MacKenzie.)

Another gallery at the center explores President Lincoln's legacy, including the ways in which he has been memorialized around the world. One video describes the Lincoln Memorial's role as a gathering place for the civil rights movement, while another shows how the ideas in Lincoln's speeches resonate today. One area describes how different presidents have been inspired by Lincoln's words and ideas, and another contains artifacts showing Lincoln's evolution as a pop-culture icon. (Photograph © Maxwell MacKenzie.)

Ford's Theatre Society and the National Park Service together offer an array of educational programs. These programs draw on President Lincoln's story to help students and teachers explore the challenges he faced and learn about his leadership qualities. Here, students participate in an oratory program in which they celebrate President Lincoln's birthday by speaking his great words from the Ford's Theatre stage. (Photograph by Gary Erskine; FTS.)

Through the Catherine B. Reynolds Civil War Washington Teacher Fellows summer institutes, Ford's Theatre partners with other historic sites to offer teachers the chance to walk in the footsteps of Lincoln, Frederick Douglass, and other historic figures. The society also offers distance-learning programs that allow students from around the world to videoconference with National Park Service rangers and society education staff to learn about Lincoln and his legacy. (Photograph by Gary Erskine; FTS.)

Ford's Theatre Society annually awards its Lincoln Medal to outstanding individuals who exemplify the qualities embodied by Pres. Abraham Lincoln—including courage, integrity, tolerance, equality, and creative expression—through their superior achievements in leadership, education, culture, or service to Ford's Theatre. Through 2013, the honor had been bestowed upon 52 people over the 45 years of the society's existence. At left, Maya Angelou is recognized for her accomplishments in civil rights and writing; below, Elie Wiesel (left) receives the Lincoln Medal from Ronald O. Perelman for his writing and leadership in understanding the personal effects of the Holocaust. (Left, photograph by Reflections Photography; below, photograph by Margot Schulman.)

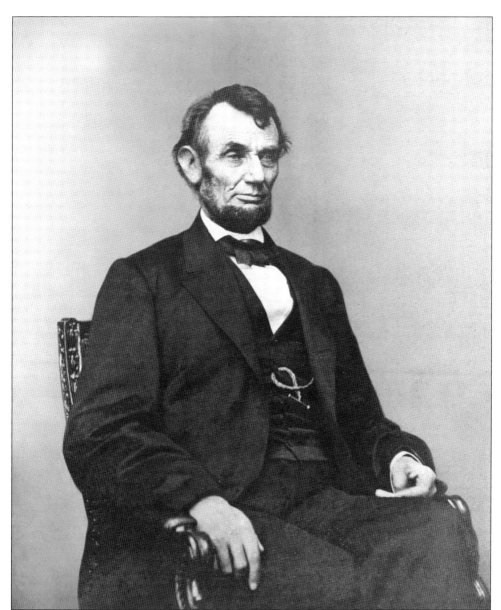

More than 150 years after his election to the presidency, Abraham Lincoln remains an enigma. Born to illiterate parents, he received only one year of formal education and conducted himself with so much humility that he was dismissed as a rube by much of Washington society. Yet Lincoln is regarded as one of the United States' greatest presidents and is revered around the world. He understood deeply the moral and legal compromises that created the country, and he overcame great personal and political challenges to win the Civil War, preserve the Union, and end slavery. He wrote and spoke with timeless eloquence about the shared values of the American people and how they apply to issues of public policy that still affect citizens today. Yet amidst these challenges, Lincoln made time to quietly attend the theater. Lincoln understood that the arts offer people temporary escape from the daily pressures of their occupations and help them better understand the higher purpose of their vocations. It is for that reason that high-quality theatrical productions continue to be presented at Ford's Theatre today. (Photograph by Anthony Berger; LOC.)

Bibliography

Bernham, William Burton. *Life of Osborn H. Oldroyd*. Washington, DC: Beresford Press, 1927.

Cochran, Robert D. *Tensions and Creativity: Baptists in the District of Columbia, 1802–1852*. Washington, DC: District of Columbia Baptist Convention, 2000.

Green, Constance McLaughlin. *Washington: Village and Capital, 1800–1878*. Princeton, NJ: Princeton University Press, 1962.

Grieve, Victoria. *Ford's Theatre and the Lincoln Assassination*. Alexandria, VA: Parks and History Association, 2001.

Lee, Richard M. *Mr. Lincoln's City*. McLean, VA: EPM Publications, Inc., 1981.

Melder, Keith. *City of Magnificent Intentions: A History of Washington, District of Columbia*. Silver Spring, MD: Intac, Inc., 1997.

Olszewski, George J. *Restoration of Ford's Theatre*. US Department of the Interior, 1963.

Swanson, James L. *Manhunt: The 12-Day Chase for Lincoln's Killer*. New York, NY: HarperCollins Publishers, 2006.

Wilmeth, Don B. and Christopher Bigsby. *The Cambridge History of American Theatre*. Cambridge, UK: Cambridge University Press, 1998.

About the Organization

One of the most visited sites in the national capital, Ford's Theatre reopened its doors in 1968, more than 100 years after the assassination of Pres. Abraham Lincoln. Operated through a partnership between Ford's Theatre Society and the National Park Service, Ford's Theatre is the premier destination in the nation's capital to explore and celebrate Abraham Lincoln's ideals and leadership principles of courage, integrity, tolerance, equality, and creative expression.

The mission of Ford's Theatre Society is to celebrate the legacy of Abraham Lincoln and explore the American experience through theater and education. For its accomplishments, the organization was honored in 2008 with the National Medal of Arts, the highest award given by the US government to artists, arts institutions, and arts patrons.

For more information about Ford's Theatre, visit www.fords.org.

Discover Thousands of Local History Books Featuring Millions of Vintage Images

Arcadia Publishing, the leading local history publisher in the United States, is committed to making history accessible and meaningful through publishing books that celebrate and preserve the heritage of America's people and places.

Find more books like this at
www.arcadiapublishing.com

Search for your hometown history, your old stomping grounds, and even your favorite sports team.

Consistent with our mission to preserve history on a local level, this book was printed in South Carolina on American-made paper and manufactured entirely in the United States. Products carrying the accredited Forest Stewardship Council (FSC) label are printed on 100 percent FSC-certified paper.